PHOTOGRAPHIC DEVELOPING IN PRACTICE

PHOTOGRAPHIC DEVELOPING IN PRACTICE

Geoffrey Attridge

DAVID & CHARLES
Newton Abbot London

An Element technical publication
Conceived, designed and edited by
Paul Petzold Limited, London

First published in 1984
Second Impression 1985

British Library Cataloguing in Publication Data
Attridge, Geoffrey
 Photographic developing in practice.
 1. Photography—Developing and developers
 I. Title
 770'.28'3 TR295

 ISBN 0-7153-8407-4

Designer Roger Kohn
Illustrator Janos Marffy

Typeset by ABM Typographics Limited, Hull
and printed in Great Britain
by Butler and Tanner Ltd, Frome
and Edwin Snell Printers, Yeovil
for David & Charles (Publishers) Limited
Brunel House Newton Abbot Devon

CONTENTS

CONTENTS

1 WHAT IS DEVELOPMENT?

However instant and automatic a photographic process may appear, the only systems currently of use to the photographer rely on the light-sensitivity of silver salts and the ability to develop an image if a transparency or a print is to be made. The ability to carry out and control development is an important aid to the photographer who wishes to obtain the best possible results.

Exposure of a film to light causes an invisible *latent image* to be formed. Only with development does this image become visible. Additional chemical treatments – fixing and washing – and finally, drying, complete the processing stages (to make the negative stable) to produce a negative (fig 1.1). The negative itself is rarely the final aim. You usually want a *positive* print, ie, one in which the subject highlights appear light in tone and the shadows dark. Such a print requires the same sequence of exposure and development as the negative, and the processes are shown in fig 1.2.

The chemical solutions which do most of the work, and those considered first, are developers and fixers.

Developers

Developers work by transforming (in chemical terms *reducing*) the exposed light-sensitive silver salts, in the photographic *emulsion* coated on the film or paper base, into metallic silver while leaving the unexposed silver salts unaffected. Development requires certain specific types of chemical – with, of course, the universal photographic solvent, water. Most important is a *developing agent* to reveal the image. However, this simple solution will not usually work without the presence of an *accelerator*, an alkali such as washing soda, which gets development going. The solution at this stage may be quite active but is quickly destroyed, or *oxidised*, by oxygen in the air. Consequently, it is difficult to keep and rely upon for consistent results. A *preservative* is therefore added to keep aerial oxidation at an acceptable level. The solution is then active and stable in use but may not be very good at distinguishing between exposed and unexposed grains of silver salts and developing only those which have been exposed. Unexposed grains may also be developed to an objectionable degree, causing *fog* – darkening the negative and, worse, making prints look dull and unin-

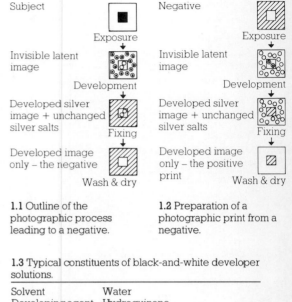

Subject — Exposure
Invisible latent image — Development
Developed silver image + unchanged silver salts — Fixing
Developed image only – the negative — Wash & dry

Negative — Exposure
Invisible latent image — Development
Developed silver image + unchanged silver salts — Fixing
Developed image only – the positive print — Wash & dry

1.1 Outline of the photographic process leading to a negative.

1.2 Preparation of a photographic print from a negative.

1.3 Typical constituents of black-and-white developer solutions.

Solvent	Water
Developing agent	Hydroquinone
	Metol
	Phenidone
Accelerator	Sodium carbonate (washing soda)
	Sodium tetraborate (borax)
Preservative	Sodium sulphite
Restrainer	Potassium bromide
	Benzotriazole

teresting. This can be very largely prevented by adding a *restrainer* or *anti-foggant* which is the final chemical you require for a practical developer. The developer thus contains:

Water
Developing agent
Accelerator
Preservative, and
Restrainer

Typical identities for the chemicals are shown in fig 1.3, some of which are familiar household substances.

Mixtures containing two developing agents often have greater power of development than the sum of the two used separately. This effect, known as *superadditivity*, is widely used to make developers which work quickly and need only a small concentration of one of the two developing agents to achieve the desired results. Typical modern developers use either metol and hydroquinone or Phenidone and hydroquinone. The

formula of a simple developer solution is given in fig 1.4.

1.4 A simple metol–hydroquinone (MQ) developer. Du Pont 53D.

Metol	1.0g
Sodium sulphite (anhydrous)	15.0g
Hydroquinone	4.0g
Sodium carbonate (anhydrous)	22.5g
Potassium bromide	0.63g
Water to	1.0 litre

After development

The developed negative contains, after development, all the unchanged and insoluble silver salts present in the emulsion. The undeveloped grains are still sensitive and will darken if left in the light. This process tends to be uneven and will, in time, make the negative useless if you do nothing to prevent it. The light-scattering residual salts would, in any case, prevent you from getting sharp prints. The light areas of a print will also darken and ruin the picture even though the scattering effect of residual salts may not be noticeable. What you have to do is to *fix* the developed film or print.

Fixing works by treating the material with a solution containing a substance, typically sodium thiosulphate (the photographer's hypo), which chemically attaches itself to silver salts and forms a *complex* salt which is soluble. The light-sensitive salts thus dissolve in the fixing solution and the last traces of silver and fixing salts are removed by a final wash in running water. The fixing solution is usually made slightly acid in order to prevent any further development and staining caused by the inevitable carry-over of developer into the fixing bath. Many acids decompose hypo so the weakly acidic salt potassium metabisulphite is commonly used. After it has been in the fixer for about one minute, you can follow the progress of fixing a film under normal room lighting. A definite change takes place when the milky (scattering) appearance of the emulsion disappears, or *clears*. As a simple rule, it is customary to fix films for twice the clearing time if no other instructions are given. A formula for a simple acid fixer is given in fig 1.5.

1.5 A fixing solution acidified by the addition of potassium metabisulphite, which does not decompose the hypo present.

Sodium thiosulphate crystals (hypo)	400g
Potassium metabisulphite	25g
Water to	1 litre

A refinement of this procedure is the addition of a *stop* bath. This arrests development after the requisite time by reducing the alkalinity. (A less effective alternative is simply to rinse the film in water.) The stop bath is often conveniently combined with the fixer but to obtain the longest possible life from the fixer it is advisable to avoid carrying developer directly into it and so a separate stop should be used. A typical stop bath may contain dilute acetic acid (as in vinegar) or potassium metabisulphite. Neither of these will do much harm to a subsequent fixing bath. Suitable dilutions for stop baths are given in fig 1.6.

1.6 Stop baths acidified by the use of (a) glacial acetic acid, and (b) by potassium metabisulphite.

	(a)	(b)
Acetic acid (glacial)	20ml	–
Potassium metabisulphite	–	50g
Water to	1 litre	1 litre

If you wish to accelerate the drying of film by use of a high temperature you may find it necessary to harden the emulsion to avoid damage. You can use separate hardening baths but it is more convenient to harden the coating during fixing. This approach leads to the use of acid-hardener-fixers which, thus, have three important jobs to do. In fig 1.7 hardening is done by the presence of potassium alum.

1.7 An acid-hardener-fixer in which the hardening is done by the potassium alum present.

Sodium thiosulphate (hypo)	360g
Ammonium chloride	50g
Sodium sulphite (anhydrous)	15g
Acetic acid (glacial)	14ml
Boric acid	7.5g
Potassium alum	15g
Water to	1 litre

NB The sodium sulphite is included to protect the hypo from decomposition by the acetic acid. Without that protection sulphur would appear as a yellow precipitate and the hypo concentration and acidity of the fixer would be wrong.

1 An indoor portrait by existing light with fast film and standard development which required a rather impractical 1/15 sec shutter speed. Even marginally modified processing could have improved the situation with an effective increase in film speed.

2 Developing films and prints yourself allows you to control the image as it forms and bring it as close as possible to what you visualised as a final print when taking the photograph.

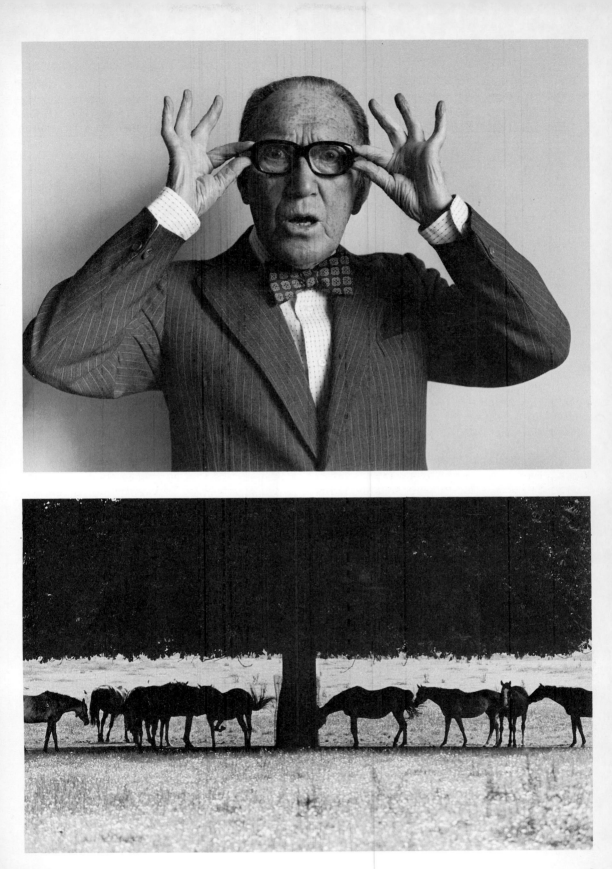

A further aim in formulating fixers is to make them work quickly. Among the methods used for speeding things up is to add an ammonium salt to a conventional fixer or to replace the hypo by ammonium thiosulphate. The additional ammonium salt added to a normal fixer is usually ammonium chloride (sal ammoniac) as shown in fig 1.7. Rapid fixers are convenient but if fixing is prolonged or if temperatures above 20°C (68°) are used, the image may become bleached, particularly with fine-grain materials such as printing papers.

In order to remove silver complexes and fixing salts and so ensure a stable negative or print, a lengthy wash in running water is needed. This should preferably be at the same temperature as the rest of the process and 20°C is the standard for conventional black-and-white development. Lower temperatures require increased washing times while higher temperatures may cause a very fine wrinkling-up of the emulsion, known as *reticulation*, which shows as an unwanted texture in any print made from the negative.

After washing, it is necessary to avoid uneven marks caused by droplets formed on the film surface during drying. You can eliminate these by a final rinse in a dilute solution of *wetting agent* such as a photographic product specially purchased or a commonly available washing-up liquid. The surplus surface water then drains right off the film when hung up to dry and any remainder is spread uniformly. As an alternative you can remove as much surface water as possible and then rinse the film in distilled (demineralised) water. In this case droplets may form on the film surface during drying but no solid residue will remain when dry and any marks will be much less noticeable than with tap water.

To dry, you should simply hang the film up by one end in a suitably clean place in order to avoid dust specks on the negatives. Drying can be accelerated by using *gentle* heating, typically from a fan heater or even a hair drier if a drying cabinet is not available. However, it is important to avoid overheating, which may make film emulsions reticulate or even melt. Printing paper is usually made to withstand hotter drying conditions than film but you should still take care to avoid overheating.

Development variables

If a developer is made up correctly, development for the standard time suggested by the manufac-

A

D

G

B

C

E

F

1.8 The effects of over- and underdevelopment on the negative film and on the prints made. **A** Under-developed, negative rated at standard speed, **B** correctly developed, **C** overdeveloped, negative rated at standard speed, **D** negative **A**, printed on normal grade of printing paper, **E** negative **B**, printed on normal grade of printing paper, **F** negative **C**, printed on normal grade of printing paper, **G** negative **A**, best print, harder grade, **H** negative **C**, best print, softer grade. Prints **D–E** have all been made on the same grade of paper for comparison purposes.

H

turer will usually give you the best result, provided that the temperature is also standardised. A shortened development time gives a weaker image while prolonged development will give a stronger one. Negatives with varied development times are shown in fig 1.8 together with prints made from each. The pictorial effects of varying the negative process are clearly visible.

The rate at which development of an emulsion takes place depends on a number of factors, starting with the rate at which the developer solution penetrates the emulsion. An important influence is the activity of the developing agents which, in turn, depends on the alkalinity of the solution – which also affects the rate of developer penetration! There are too many interrelated variables to give a simple analysis of the dependence of the required development time on the development temperature. In common with many other chemical reactions, photographic development is speeded up by higher temperatures. The extent of the speeding up depends on the formulation of the solution, particularly on the exact developing agents used.

The relationship between development time and temperature is, fortunately, consistent enough for you to work out the required time for any temperature within a reasonable range. This is, however, only true for a restricted range of (common) developer types.

Variation of developer temperature is best avoided but a useful time and temperature chart (fig 1.9) enables you, if necessary, to vary de-

velopment times to compensate for small departures from the standard working temperature of 20°C. Diagonal lines relate time and temperature. Thus, a film which requires 5 min development at 20°C is seen to need approximately 9½ min at 13°C (55°F) but only 3¾ min at 23°C (73°F).

Colour processing is most intolerant of errors of time or temperature. If you are looking for the best results you cannot normally make any easy trade-off between time and temperature in a colour process. Learning to operate at standard times and temperatures with black-and-white processes is therefore good practice for processing colour materials.

Controlling development

If consistently good results are to be obtained you have to be careful about the way you develop both film and paper. Unless there are very good reasons for doing otherwise, you should follow what the film manufacturer suggests. Usually,

1.9 Development time and temperature equivalence for films developed in metol-hydroquinone and Phenidone-hydroquinone developers.

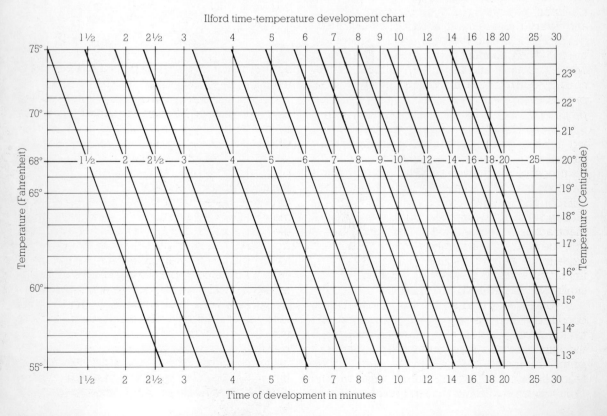

Ilford time-temperature development chart

Temperature (Fahrenheit)

Temperature (Centigrade)

Time of development in minutes

there are definite recommendations about the treatment of every photographic film or paper and every processing solution. Following a few general points can, however, save you a lot of trouble. The important points concern the way in which you store and use solutions. Note the recommended storage life of solutions and their processing capacity (ie, how many films can be processed in a given volume of solution). Some manufacturers make recommendations about giving longer development with increasing use as well as quoting a maximum number of films to be processed in a given volume. You should follow such instructions carefully. An exhausted developer will not give good results. The temperature and time of development should be within the manufacturer's recommended limits and, if possible, be consistent at values which you know by experience will give a satisfactory result. Another important variable is agitation, which should be similarly standardised.

If you take care to standardise development conditions there is a good chance that your negatives will be consistent and, provided you control the exposure stage, you will obtain satisfactory prints. The printing stage also requires consistency and you should take care to standardise print processing within the recommended limits

3 Selecting and controlling the best developing and printing conditions helps you towards a satisfactory rendering of both the subtle tones and the fine detail that characterise the subject.

so that frustrating disappointments can be kept to a minimum.

Control and care in the darkroom can eliminate print faults caused by over- or underdevelopment or uneven processing of negative or print. Your prints will appear brilliant and of a satisfactory neutral or other, chosen, hue.

Relationship to the subject
Once you have mastered the control of development and can achieve consistent results the way is clear for a further degree of control. You will see from manufacturers' data that the film development time can be varied to cope with different printing conditions, particularly different types of enlarger. A higher contrast negative, produced by increased developing time, is usually required for satisfactory prints to be made using a *diffuser* enlarger. If, on the other hand, you use a *condenser* enlarger you will get the best results by using the lower of the two published developing times. If the subject luminance range (the difference between the darkest shadow and the

lightest highlight) is markedly different from the average you can make a suitable compensation to the development time. In this way you obtain negatives that you can print to get the optimum reproduction of the subject tones.

The control of development is an integral part of the very methodical photographic work typified by the 'zone system' of Ansel Adams. Such systematic work, based on knowledge of the subject of the photograph and the properties of the materials used, can help you get the most from photography – even if you do not quite match the methods and the quality Ansel Adams achieved.

4 In many cases, standard development, carried out with care, is all you need. Here, the film manufacturer's recommended general-purpose fine-grain developer was used exactly as specified. This gave a negative that was easy to print and had the right contrast and fine detail for the mood of the picture.

5 A yellow filter was used when shooting, to emphasise the cloud shadows. Controlled development however, contained the extremes of contrast – giving detail in the large areas of shadow, yet retaining the silvery highlights.

15

2 BEING PREPARED

Before you can develop a film or a print you must be suitably equipped to to do it. Preparations include having the right chemicals ready for use, processing tanks or dishes of the appropriate sizes and the necessary thermometer and clock to ensure the accuracy of the process. Care is needed at all stages from the selection of chemicals to the drying of the film or paper after processing.

Sources of solutions

In most cases the manufacturer of photographic film or paper recommends a suitable developer (or range of developers) for the product. These are usually the ones most likely to give you the best results. Sometimes, however, they are supplied in forms or quantities which can be inconvenient to the small-scale user. This has encouraged independent manufacturers to market photographic chemicals in convenient packs for the amateur and, in some cases, special benefits are claimed for the solution in use – such as increased film speed, improved grain or greater sharpness. Alternative processing solutions are also available for all scales of black-and-white and colour processing and there is considerable competition to supply such solutions to photographic units and processing laboratories as well as the amateur.

The use of individual or 'raw' chemicals for making up processing solutions from formulae published by film manufacturers or others is the most demanding method of solution preparation. It is favoured by a few dedicated workers and by many large processing laboratories. Initially, it involves purchasing the required substances, taking care to select 'photographic grade' chemicals where available. The necessary chemicals can often be obtained from the film manufacturers, but there are also specialist suppliers who advertise in the photographic press. Making up solutions requires an ability to weigh out chemicals, often to an accuracy of 0.1g or better. If you have neither balance or scales of the required accuracy, nor the expertise to use them, the job is best not attempted.

Many photographic solutions are available as packs of powdered chemicals which merely require dissolving in water according to accompanying instructions, as shown in fig 2.1a. If you

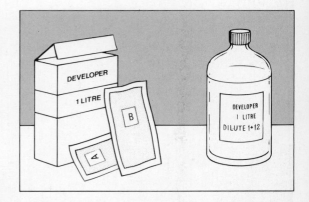

2.1 Developers: **a** Two-part powder kit. Fully dissolve A before adding B to the solution. **b** Concentrated solution. Dilute according to the instructions for use.

are lucky there may be only one packet to dissolve; do it by slow addition of the powder to the stated volume of water, at the temperature suggested and with constant stirring. It may be necessary to make a final addition of water to get the correct overall volume. In any case you will require a suitable measure. When you have to add more than one powder it is essential that each be fully dissolved before you add the next in the order stipulated by the maker. If you do not take this precaution you may end up with a solution accompanied by undissolved chemicals which you cannot then get into solution. Such a mixture will probably not work very well.

You can buy more simply formulated chemicals as concentrated solutions needing only dilution for use, as illustrated in fig 2.1b. All you have to do then is to measure the final volume accurately. Once again, you may find that you have to add more than one concentrated solution. In each case, carefully follow the instructions provided and ensure full mixing before adding the next component. Concentrated solutions which you dilute for use are particularly handy because small or non-standard volumes can easily be made up as required. The concentrated stock solution is usually quite stable and you can keep it in a sealed bottle on the shelf for lengthy periods without significant deterioration. The mixing precautions to be taken for powder and liquid packs are similar and vital; they are illustrated in fig 2.2 which shows the gradual addition and constant

2.2 Adding a powdered chemical to the stirred solution. Addition must be gradual and stirring should not be so vigorous as to cause a vortex to be formed. Fully dissolve A before adding B.

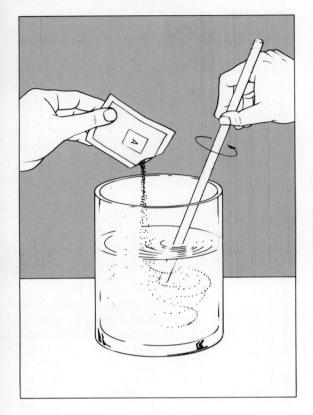

stirring required in both cases.

If you keep or handle chemicals at home, make sure they are stored securely and out of the reach of children.

What you need to make up solutions

Once you have bought the necessary processing chemicals you need to make up the solutions. For this you need a large container, at least 50% larger than the volume you want to make up. This is so that you can stir the solution thoroughly without too much risk of spilling it over the edge. Suitable containers (and stirrers) may be made from PVC (polyvinyl chloride), Polythene (polyethylene), stainless steel, glass or other inert materials. Galvanised buckets or containers are chemically unsuitable and enamelled containers are suitable only if the enamel is unchipped and uncracked. Copper, brass and aluminium containers should not be used, although copper has some limited suitability for the handling of bleach solutions. A list of common materials and the photographic suitability of each is given in fig 2.3. You should wash the vessels thoroughly, together with all utensils immediately before and after use to avoid cross-contamination of solutions and the possible

2.3 The photographic suitability of constructional materials for mixing, storage and processing vessels. (✓ suitable, X unsuitable.)

Material	Application: Mixing	Solution storage and processing use: Developer	Fixer	Bleach	Wash
Glass	✓	✓	✓	✓	✓
Porcelain	✓1	✓1	✓1	✓1	✓1
Vitreous enamel	✓1	✓1	✓1	✓1	✓1
Aluminium	X	X	X	X	X
Stainless steel	✓	✓	✓	X	✓
Nickel	X	X	X	X	X
Iron	X	X	X	X	X
Titanium	✓	✓	✓	✓	✓
Zinc (and galvanised iron)	X	X	X	X	X
Bronze	X	X	X	X	X
Copper (and brass)	X	X	✓2	✓2	✓2
Polytetrafluorethylene (PTFE)	✓	✓	✓	✓	✓
Polyethylene	✓	✓3	✓	✓	✓
Polypropylene	✓	✓	✓	✓	✓
Perspex	✓	✓	✓	✓	✓
Polyvinylchloride (PVC)	✓	✓	✓	✓	✓
Nylon	✓	✓	✓	X	✓
Hard rubber	✓	✓	✓	✓	✓

1 Do not use if surface is cracked or chipped.
2 Only use with careful pre-test to check suitability.
3 Low density polyethylene is too porous for developer storage, high density polyethylene is satisfactory.

contamination of clothing or skin from accidental contact with chemicals.

When you mix chemicals, and particularly developers, try not to stir so vigorously that you form a vortex in the liquid. This may draw air into the solution which will rapidly spoil a developer if allowed to continue.

If in doubt about the suitability of a constructional material you can test a sample by partial immersion in the solution in question at, say 40°C, for 14 days. Examine the sample of material for chemical attack and test the photographic activity of the solution. Use only if both tests are satisfactory.

Thermometers

A thermometer is needed when making up solutions because the makers often suggest suitable temperatures at which to make them up. Wash the thermometer in cold water immediately after use to avoid the risk of contamination.

When you buy a thermometer you should bear in mind the uses to which you will put it. If you do not anticipate doing any colour processing then you can probably use a typical mercury thermometer calibrated at each degree Centigrade. Many other types of thermometer are also available, including simple dial types as well as more expensive LED (light emitting diode) readout devices or other digital displays. These digital examples are often much easier to read when checking the temperatures of colour developing solutions requiring accuracy to within 0.25°C. You should check the specification of any thermometer rather carefully. As with car speedometers, the numbers on the scale are no guarantee that the instrument is accurate. Check that it is sufficiently so for your purposes, and that the indicated temperature is easy to read.

Traditional mercury thermometers are made in a variety of patterns for photographic use. There are types which rest conveniently in dishes, and others that can be hooked onto the rim of a processing tank. It is helpful if the scale of this last type of thermometer is arranged to be above the liquid surface. If it is not, you may have difficulty in reading the temperature accurately.

To hold your made-up solution, and to exclude air, choose a bottle equal in capacity to the volume mixed and fitted with an air-tight stopper or screw cap. Label the bottle with the name of the solution, its dilution (if any) and the date when it was made up. If you share a darkroom you should also put

your name on the bottle. Leave room on the label for a record of the number of films processed.

For large-scale mixing of solutions it is impractical to use manual methods. Instead, for volumes greater than about 15 litres, you can use special mixing equipment comprising a container equipped with castors and a pumped outlet so that you can carry out mixing alongside a processing machine or storage tank and then transfer the solution easily. As with manual methods, vortices should be avoided in mixing developer solutions in order to prevent undue aerial oxidation.

Storage

As soon as you start developing, and especially printing, you have the problem of storing photographic materials and chemicals. You will probably have set aside an area to work in which you can also use for storing the mixing and developing equipment. But you have to consider the special needs of materials and chemicals. Photographic films and papers, especially for colour photography, usually benefit from being kept at lower than room temperatures. Colour materials (and black-and-white, if you have room) can be stored in a domestic refrigerator at, say, 10°C (50°F) if they are in their original air-tight wrapping or otherwise protected from damp. Alternatively select as cool and dry a storage area as you can.

As photographic solutions are often stored in high concentrations, try to avoid cooling them to below about 15°C (59°F) otherwise you may find that chemicals crystallise from them and cannot then be redissolved. In this condition, a solution will not work properly and you will probably fail to obtain the results you expect. Storage at temperatures markedly higher than 20°C, on the other hand, may speed up undesirable changes in solutions and spoil them. You should aim to store chemicals sealed in full air-tight bottles at temperatures of between 15°C and 20°C.

Glass bottles can be used for long-term storage or you can buy plastic containers designed specially for storing photographic solutions. Some plastic bottles, however, are too porous to the oxygen in the air to make them suitable for long-term use with developers – check this point when buying.

Bottles may be kept full in a number of ways. One useful idea is to top up a partially emptied bottle by adding clean glass marbles to take up the volume of solution used. A second method is to use specially made compressible plastic bottles

which you squeeze to expel air before sealing with a screw cap. Both alternatives are illustrated in fig 2.4.

If you are storing really large volumes of solutions, sealed bottles or similar containers are impractical. You can, however, use large storage tanks equipped with floating lids and, ideally,

6 Correct storage of chemicals is especially important where all your pictures are on a single film roll and there are no second chances. Where shadow detail is vital to the picture you must be able to rely on good quality development.

filled or drained from the bottom. Large volumes are much less prone to atmospheric effects than small. The floating-lid system is particularly suitable in such cases. If you use a pumped filling method then you can install storage at a high level and feed piped solutions by gravity to individual processing rooms within the work area. The mixing and storing of large volumes of solution is illustrated in fig 2.5.

You will have noticed that sensitive materials

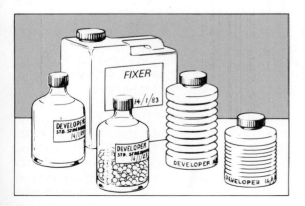

2.4 Storage bottles for photographic solutions: full glass bottle, half-full glass bottle made up to volume with marbles, plastic can of fixer – suitable for large volumes – full and half-full concertina-like plastic bottles (half-full bottle is compressed to volume of remaining solution to exclude air, and then sealed).

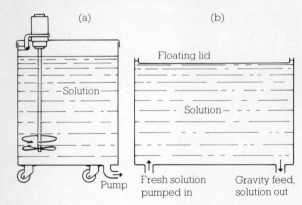

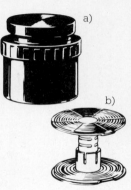

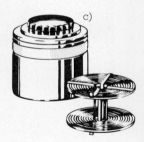

2.5 Mixing and storing large volumes of solution. **A** An electrically powered bulk mixer. The stirrer motor can be tilted to bring the stirrer to other parts of the mixing vessel. **B** A storage tank equipped with feed and outlet pipes and a floating lid. If the tank is mounted in a high position the solution can be fed to users by gravity. A pump must then be used for filling the tank.

2.6 Developing tanks and spirals: **A** plastic developing tank, **B** plastic spiral adjustable to hold 35mm, 127 or 120 film, **C** stainless steel tank and spiral for 35mm film.

7 With suitable developing chemicals and the right equipment you can make the most of photographic opportunities as they occur. An unplanned picture may be 'saved' in processing.

and processing solutions have different storage requirements. Even if you cannot meet these exactly try to avoid storing film and chemicals near one another. There is always a risk of chemical contamination and this is minimised by separate storage. If contamination occurs, much time may be wasted in working out what has gone wrong, and much money in replacing materials. You may also lose an unrepeatable photograph! So take good care of materials and chemicals.

Equipment for developing film and paper

The most awkward job is the development of lengths of 35mm or 120-size roll film. While it is possible to process such films, in total darkness, by dipping them into a solution and running them through the liquid from hand to hand it is difficult to do this consistently and is very tiring. The more practical method is to support the film in a convenient spiral frame totally immersed in a small volume of solution inside in a light-tight processing tank designed to hold the spiral and to allow processing operations to be carried out in normal room-lighting. You can buy a spiral and tank which can cope with both 35mm and 120-size film. Such equipment is generally made of plastic. For some purposes, especially colour processing, stainless steel tanks and spirals are often preferred as being easier to clean and resistant to chemical penetration and consequent contamination problems. These are more expensive than plastic equipment, not adjustable for different film sizes and may be more difficult to load. Examples

of both plastic and stainless steel spirals and tanks are illustrated in fig 2.6.

Spirals, depending on their construction, are loaded with film, either from the edge inwards or from the centre outwards. Both operations require some practice and are described in Chapter 3.

With materials other than 35mm or roll film you will have to use dish processing for small-scale work. The dishes are simply shallow trays larger than the size of paper or sheet film to be processed by at least 25mm (1in) in each direction. They may be specially purchased photographic processing dishes made of plastic, stainless steel, enamelled iron or even pottery. Non-photographic dishes may also be perfectly satisfactory provided that they are chemically inert and sufficiently robust to be lifted by one edge when half-full of solution. You need as many dishes as you have processing stages and you may use extra large dishes for the final processing steps.

Washing of 35mm and roll films is best carried out in the spiral tank. Sheets of film or paper, however, need either water flowing through a shallow dish or sink, or a wash tank in which sheets are supported in a vertical rack while the water flows across them. Paper prints may, additionally, be washed in special troughs through which the water flows with a swirling action to agitate the wash and circulate the prints to achieve the maximum washing efficiency. Processing dishes and washing equipment are shown in fig 2.7.

The equipment designed for small-scale use is not generally ideal for processing large numbers

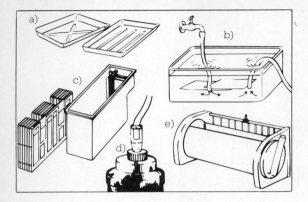

2.7 A Processing dishes, transparent plastic and stainless steel, **B** washing: dish input and syphon, standpipe in sink, **C** washing tank with vertical racks for prints, **D** washing a film in a spiral tank, **E** rotary print washer, strong swirling action gives efficient washing.

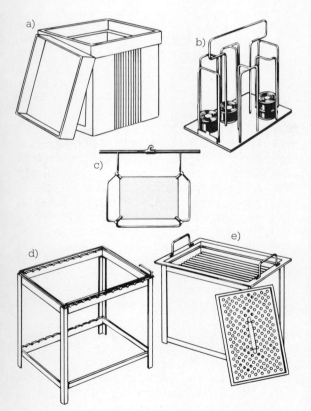

2.8 Moderate-scale processing equipment: **A** 13.5 litre (3 gallon) processing tank with cover and floating lid, **B** rack for processing 35mm and roll film in spirals, **C** clip hanger for developing sheet film in a 13.5 litre tank, **D** sheet film processing rack to hold clip hangers, **E** print processing basket.

of films at a time. You can use spirals in cylindrical tanks for up to ten or so 35mm films at once, but for greater numbers you need other methods. Probably the simplest is to use similar spirals but to support them in batches of twenty or more in special racks designed to fit into a standard (13.5 litres 3 gallon) processing tank. Such a tank and the processing rack are shown in fig 2.8. With this method you transfer the rack of films from tank to tank so that, as with dishes, you need as many tanks as there are solutions and washes in the processing sequence.

Three gallon tanks of the standard type can also be used for the processing of sheet film and printing paper up to 20.3 x 25.4cm (8 x 10in) in size, provided that the material is supported in clip hangers of the type shown in fig 2.8 or in some similar arrangement.

When tank processing of film or paper is carried out on the scale described, agitation is effected by lifting the material out and lowering it again into the solution at regular intervals. It is therefore not a 'light-tight' process and you must carry out development and stop operations in the safelight conditions specified for the materials. A darkroom is essential for developing films at this scale of operation.

In commercial photographic units three gallon, or larger-scale, hand processing is widely used. A greater demand can be met by various types of processing machine. A typical, versatile, example (fig 2.9) shows how rollers are used to drive 35mm, roll or sheet film through specially formulated solutions. In some cases the relatively flimsy 35mm or roll films must be attached to stiffish leader material in order to flow through the machine satisfactorily; in others, the leading edge of a film is crimped to stiffen it. Such machines are equipped with thermostatic control of solution and wash temperatures. The speed of film transport, which governs the processing times, is also carefully controlled but may be adjusted by the operator to suit the needs of different films. In most cases, solution activity is maintained by chemical replenishment of all baths, which takes place automatically. Very efficient washing methods are used to reduce the processing time and the film is dried before emerging from the machine into your waiting hands or, more usually, a receiving bin. Similar machines are also used for large-scale processing of photographic paper – particularly of the resin-coated type.

For the largest sheets of film manual methods

2.9 Principles of roller-transport processing. The time of immersion in any tank (1, 2, 3 . . . n) is governed by the speed of film transport and the length of the rack of rollers in the tank concerned. Drying is achieved by introducing warm dry air to the film through the nozzles shown.

8 Control over the film development and printing stages gives you the opportunity to create special effects, as in this daylight picture in which the highlights are seen prominently against dense shadow. A red filter was used at the shooting stage to enhance the contrast, particularly between sunlit and skylit areas (overleaf).

can be used and for this you need large dishes. It is more usual for such materials to be processed in large roller-transport machines essentially similar to the type already described.

Darkness

For any kind of photographic processing you need to be able to control the light striking the film or paper. For most negative films the control is to exclude light totally until all development has been completed (after one minute in the stop bath of a typical negative process). For printing papers and special-purpose ortho- or blue-sensitive films quite a useful level of appropriate safelighting can be used – the colour of the safelight depends on the nature of the material being used and is usually specified by the manufacturer.

The means of isolating a film can be surprisingly simple. You may find it quite possible to use a dark cupboard when loading a film spiral and putting it into a light-tight developing tank. The rest of the processing can then be done in room lighting. Alternatively, you can use a changing bag and this is described in the next chapter. Once the tank has been closed you can get it out of the changing bag and develop the film, in its tank, in full room-lighting.

It is the ambition of most keen photographers to have a fully equipped darkroom and it is essential for the professional. In many cases, however, only the barest necessities can be provided. If you can set aside space for exclusive use as a darkroom then, of course, things are simpler but an improvised darkroom using a blacked-out bathroom or attic can be quite satisfactory. The essential requirements are complete darkness, sufficient space to work in and to store bottles of solutions, packs of chemicals, measures, bottles, funnels, tanks, dishes and other paraphernalia.

What to buy for small-scale processing

Apart from the film you use, it will inevitably be necessary for you to buy equipment for developing your films. You may already have about the house or at your place of work (if photography has been added to your normal duties) a range of useful bottles, containers and measures. It is highly desirable that such utensils be set aside for purely photographic use. (While most photographic chemicals are not particularly harmful you should learn to behave as though they are very poisonous. In this way you will work cleanly and carefully

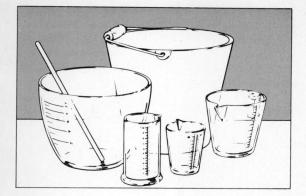

2.10 Containers and measures: 6 litre (1½ gallon) polyethylene bucket, glass graduated mixing bowl and stirrer, measuring jug, two glass measures – often graduated in cc and oz.

usually have an automatic spiral-loading device and need little skill to operate. Examples for 120 and 35mm films are shown in fig 2.12.

If you wish to print your own black-and-white negatives you need an enlarger. As choice involves personal taste and the range available is huge, only general guidance is appropriate here. You should look for a rigid construction, not prone to vibration. The ability to fit any lens of your choice is useful as is the scope for printing 6 x 6cm negatives as well as 35mm. Unless you are sure that you will never want to make colour prints you should also make sure that an enlarger which does not have a 'colour head' can, nevertheless, accept the necessary colour correction filters. With black-and-white enlargers designed also for colour printing, a drawer is provided for such

and both you and your photography will benefit.) Thus, you may need to buy some containers and measures: a range of such utensils specially designed for photographic purposes is readily available from your photographic dealer (fig 20).

As well as volumes of solutions you will also need to measure temperatures and times. A good quality thermometer (see page 18) that is both accurate to 0.25°C and easy to read is very useful and will cope with the accuracy required for all colour processes. If you do not envisage working with colour you can economise by choosing a less accurate thermometer. A luminous clock or an electronic timer equipped with an LED (light-emitting diode) display will help you to time operations requiring total darkness, and a range of suitable timers, some with an audible alarm, is available. If all your processing is to be done in light-tight processing tanks then you can simply use a good wrist-watch with seconds indication or a similarly equipped wall-clock. If total darkness is required for a process where even LED displays can be a nuisance then the audible alarm is a most valuable feature to have on a timer (fig 2.11).

If, as is most likely, you intend to process 35mm or roll film you will need to buy a suitable spiral developing tank. If a darkroom is out of the question and a changing bag does not attract you it is worth considering a developing tank designed for daylight loading. These tend to be more expensive than darkroom-loaded tanks and to be less versatile in use but do have the obvious advantage of being suitable for loading and handling throughout in normal lighting conditions. They

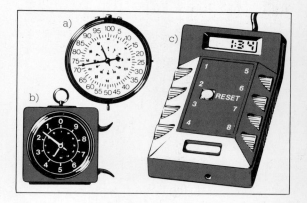

2.11 Timers: **A** stop-clock, best with luminous hands and scale, **B** timer with alarm bell to tell you when preset time has elapsed, also best with luminous hands, **C** a preset timer with up to eight separate settings and an LED read-out. A buzzer sounds at the end of each preset period.

filters above the condensers.

Black-and-white printing very seldom takes place in total darkness. You will certainly find it useful to buy a safelight equipped to give the yellow to orange illumination to which most printing papers are reasonably insensitive. It is helpful to be able to change the safelight filter to suit different types of film and paper with different sensitivities. Safelights may be mounted on a ceiling, wall or bench (fig 2.13).

For dish processing you need both the dishes themselves and, to safeguard your hands, print tongs for handling the prints in the solutions. Protective plastic or thin rubber gloves are also useful (fig 2.14).

2.12 Daylight-loading processing tanks: **A** roll-film type, **B** 35mm type.

2.13 Safelights: **A** Free-standing on bench or shelf, conventional and LED types, **B** wall-mounted type.

When you have assembled all the necessary items summarised in the check-list (fig 2.15), you are ready to start developing. The two chapters that follow explain the basic operations for black-and-white processing. In fact, the procedures involved in colour processing are not particularly different, nor are they difficult. If you can carry out black-and-white processing consistently and successfully, then, if you wish, you should be able to undertake colour processing as well.

2.14 Looking after your hands. Use print forceps (print tongs) and wear protective gloves for dish processing.

2.15 Equipment for photographic developing.

Black-and-white film
Suitable developer (check recommendations for film type)
Stop solution
Fixer (stop-fixer best)
Mixing vessels
Measures for solution volumes
Bottles of assorted sizes, with labels
Thermometer
Funnel(s)
Developing tank and spiral (*changing bag if necessary)
Scissors
Timer

Additional items for black-and-white paper
Suitable developer (usually different from film developer)
Stop solution
Fixer (not previously used for film processing)
Bottles of assorted sizes, with labels
Thermometer suitable for use in dishes
Processing dish for each solution
Pair of print tongs for each dish
Large dish or tank for washing prints
Safelight (check suitability of filter for the paper to be used)

3 DEVELOPING BLACK-AND-WHITE FILM

When you have arranged all the necessary equipment, solutions and somewhere to work you can develop your film.

Follow the instructions

The first step is to read carefully, once again, the manufacturer's data for the film. Check that you have the recommended solutions and be sure of the suggested processing times and temperatures. If you use some other developer there should still be recommended time and temperature conditions, in this case suggested by the manufacturer of the developer. Unless you have good reason to depart from the recommended conditions they should be closely adhered to if you wish to get reproducible results of the best quality. If you already have a developer and film for which no recommendations are made, Chapter 6 should be helpful to you. To some extent, the variables of time and temperature are interchangable in black-and-white processing. Various manufacturers publish information enabling you to compensate for development conditions varying from the standard. A sample is shown in fig 1.9. The slanting lines are each identified by a number showing the development time in minutes at 20°C (68°F). To use the chart, you look for a slanting line bearing the appropriate time and follow it until it cuts the horizontal line corresponding to your development temperature. Look vertically above or below the intersection and read the modified time from the scales provided. An example is described in Chapter 1.

Are you ready?

First, make sure once again that you have everything you need and that it is laid out in some logical way for ease of working. For a 35mm or roll film, that means arranging the developer, stop and fixer solutions in order of usage and measured out to the correct volume (usually marked clearly on the developing tank). You will also need the developing tank itself complete with spiral, lid and any sealing rings and caps, a pair of scissors, the thermometer and timer. You may also want a changing bag for loading the developing tank.

Before you start, you may find it helpful to glance at the simple guide (fig 3.12) to processing a film at the end of this chapter. Keep it by you for reference during the process.

Loading a spiral developing tank

It is essential that the spiral and tank be clean and dry before use. Any moisture on the spiral will make the film stick and you will be unable to load it.

Film must be handled in total darkness so make sure that you know where everything is that you need to load the tank. Also make sure you can reach and identify things by touch alone (try it first in the light but with your eyes closed). Check that you know which way to insert the film into the spiral (ie, which way the loading slots, if any, must face).

35mm film

The inner end of 35mm film is usually taped to the centre spool of the cassette while the outer end is cut to a tongue shape for loading into the camera. You can ease matters if you remember not to wind the tongue back into the cassette completely when you rewind the film. If the tongue is still accessible, cut the film at right angles between a pair of perforations close to the tongue as shown in fig 3.1B. Pull out just enough film to do this and to leave you sufficient to pull out the remainder when you are in the dark.

Once *in the dark* it is best to prise off one end of the cassette using manual pressure, the edge of a coin or, if the end is stubborn, a bottle opener or implement specially sold for the purpose. If you cannot manage this, simply pull the film gently out of the cassette through the exit, as if the film were winding through the camera. (This may be easier, but it risks scratching if grit gets into the cassette exit slot.) When you have removed the film and spool or pulled out about 30cm (12in) of film from the cassette you can insert the cut-off end into the spiral, allowing it to follow its natural curl. You load the film with its emulsion towards the centre of the spiral.

With a self-loading spiral of the edge-loading type all you have to do is to insert the cut end into the loading slots and rotate one end of the spiral back and forth (fig 3.2). A ratchet device or, in some cases, alternate thumb pressure on the film edges, allows the film to be drawn into the spiral. When you have loaded most of the film, the centre spool, or the cassette, will be close to the spiral. You can then cut across the film with scissors as close to the spool or cassette as possible and load

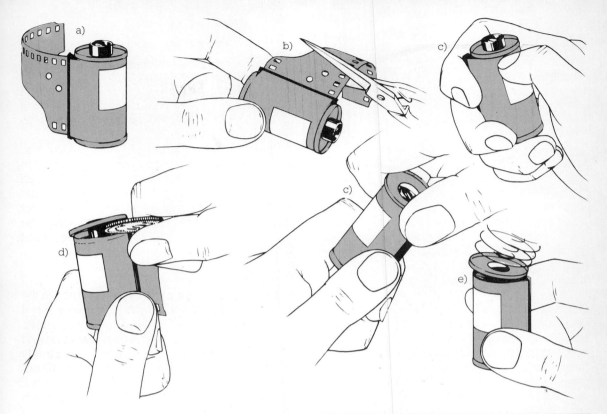

3.1 35mm cassette:
A cassette showing tongue of film, **B** cutting off the tongue, **C** two methods of opening a cassette using manual pressure only, **D** opening a cassette using a coin, **E** by striking it on a surface.

3.2 Self-loading spiral of the type shown in fig 2.6B, **A** inserting the film, **B** loading the film.

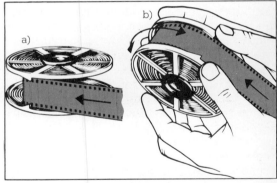

the remainder of the film into the spiral.

If, when you wish to develop a film, the tongue is inaccessible because you have wound it fully into the cassette you will have to take off the end of the cassette *in the dark*. Remove the film on the centre spool and loosely wind it off into a roll until you get to the spool. Cut the film at right angles as close to the spool as possible using the sides of the spool as a guide. You can then load the cut end into the spiral as already described. You should find that the entire length will fit into the spiral. If the tongue will not fit in, simply cut it off with

scissors. If you cannot get the film to load into the spiral examine the cut end by touch. You may have cut through perforations and therefore have sharp corners which catch in the spool rather easily. If you have this problem, then, in the dark, either trim the extreme corners off at an angle of 45° or cut across the whole width of the film between perforations and close to where you made the original cut.

The procedure you adopt when using centre-loaded spirals (fig 3.3) differs only in loading the spiral. You have to bow the film slightly between

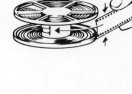
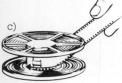
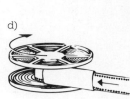

3.3 Centre-loaded spiral:
A empty spiral, **B** bowing
the film and inserting the
end, **C** loading the film,
D use of loading device.

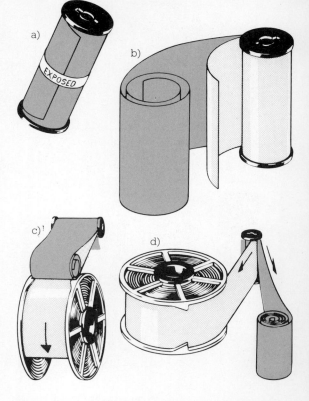

thumb and forefinger in order to make it narrower
than the gap between the two ends of the spiral.
You then gently push the cut end of the film into
the centre where it is secured by small prongs or
a clip. Keeping the film bowed, feed it into the
spiral by rotating it in one direction only while
allowing the bowed film to spring into the spiral
groove as it feeds in. Loading devices for centre-
loaded spirals keep the film correctly bowed dur-
ing insertion and loading, and are wound out-
wards along the spiral track during loading. They
can be a great help.

3.4 Loading a roll film into a
spiral of the edge-loading
type: **A** the roll film,
B unspooling the film,
backing paper with film
appearing, **C** loading the
film into the spiral,
D separation of backing
from film.

Roll film, 120 or 127

Roll films of these types are attached to the visible
backing paper, at one end only, by adhesive tape.
When you want to develop such a film, remove
the sealing strip and, *in total darkness*, unroll the
backing paper carefully until you reach the
(untaped) end of the film itself as shown in fig 3.4.
Then, insert the end into the spiral, allowing it to
follow its natural curl.

Loading the spiral is the same as for 35mm film
except that no use can be made of perforations in
locating films on centre-loaded spirals – which
therefore usually have a spring clip for this
purpose. When you have loaded most of the film
and reach the taped end, carefully tear off the
backing paper and continue loading until all the
film is in the spiral. If you prefer, you can sepa-
rate film and backing paper before starting to
load. But be prepared for an unruly length of film
and do not try to load the taped end into the spiral
first, or it may jam.

Other film sizes

Black-and-white film is rarely used in the 126 size.
If you have to deal with one you will need a 35mm
spiral but the film is not conventional for that size
and has a backing paper. To get at the film and its
backing paper there is no alternative to breaking
open the plastic cartridge. You separate the film
and backing from the sometimes sharp remains of
the cartridge and then treat it like any other roll
film, but load it into the 35mm spiral. All these op-
erations can, of course, only be carried out in *total
darkness* (fig 3.5).

The relatively rare medium-format 220 film is
the same width as 120 but has no continuous back-
ing paper. Instead, there is a paper leader and, at
the other end, a paper trailer. If you have to load
this type of film in a 120 spiral, first remove the
leader and trailer in *total darkness* and then load
in the conventional way. Check before you start
that the spiral will accept the complete length of a
220 film (the instructions for the developing tank

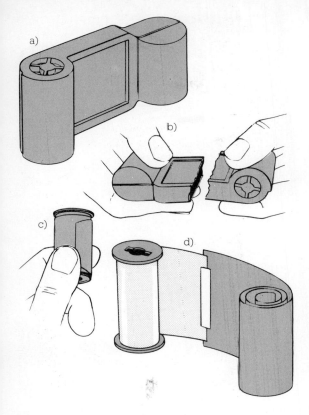

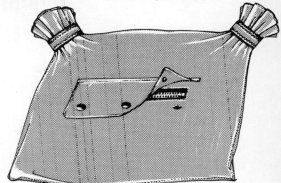

3.6 A changing bag.

3.5 Unusual film types: **A** 126 cartridge containing roll film, **B** breaking open a 126 cartridge, **C** 126 film spool with backing paper, **D** 220 film spool showing film and leader joined with sticky tape.

should tell you this). An adjustable spiral that will accept a 36-exposure 35mm film should be just about long enough to accommodate a 220 film when used at its 120 setting.

Taking care

Photographic emulsions are easily damaged so avoid touching the emulsion surface (usually the inside of the curl) at any stage of processing or handling. Touch only the edges.

Practise loading a spiral with a scrap of old film before using one that matters. If your spiral has an optional loading device you should consider buying this.

As you load a spiral, particularly the centre-loading kind, it is worthwhile gently feeling the back of the film to check whether it is kinked or uneven in any way. If it does, the film is probably not fitting correctly into the spiral groove. You may need to bow the film and unwind it to an un-kinked part and make another attempt at loading

it. If you allow the film to remain not properly fitted into the groove, adjacent coils may touch, stick together and give patchy development and useless negatives.

It is not unknown for photographers to drop un-spooled film while trying to load spirals in the dark. If this happens to you, *don't panic*. Keep your feet still and explore the working surface or, if necessary, the floor, with your hands. Start nearby and gradually increase the radius of search. Only move your feet when you are sure you won't tread on the film. When you have picked it up handle it only by the edges and locate a square end so that you can load the processing spiral.

Keeping it dark

Spiral tank loading has been described in terms of using a darkroom. If you have to make do with a cupboard under the stairs there may be adequate room but some extra scope for losing the un-spooled film, depending on what else is in the cupboard. Try to clear your working area so that if you do drop something you can find it again.

The most constricted dark space is provided by a changing bag (fig 3.6) which you can use instead of a darkroom for loading spirals. The bag is made from several layers of black-out material and is equipped with a large aperture, usually fitted with a zip fastener, protected by a button-down flap or second zip. In addition there are two short sleeves with elasticated cuffs through which hands can be inserted. To use the bag open the large aperture and place the spiral, tank and lid inside, together with the undeveloped film as it comes from the camera. Then close the aperture and push your hands into the short sleeves. Identify the tank and film by touch. Open the cassette, or break the seal on a roll film, and load the film

into the spiral, in the dark of the changing bag, as you would in a darkroom. If you use scissors take care not to cut through the changing bag from the inside.

When you have loaded the tank in the darkroom or changing bag, make sure that the top is fitted properly. You can then take the tank out and work in the normal room light.

Getting the temperature right

Use the thermometer to check the temperatures of your processing solutions before going any further. The standard for black-and-white processing is 20°C (68°F) and this is close to average room temperature. To adjust the temperature of a solution you can stand the container in water of higher or lower temperature, as required, and remove it when the adjustment is complete. You can speed this up by stirring the solution while it is heating or cooling (fig 3.7). It is best to have all the solutions at the same temperature.

In extreme circumstances, the temperature of a processing solution may change while in the developing tank. You can encounter this problem particularly with high temperature processes. One remedy is to stand the tank to about three-quarters of its height in a large volume of water already adjusted to the temperature you want (fig 3.7B). Alternatively, start with the solution slightly above the standard temperature so that it averages out correctly over the whole development time. Instructions for this method are usually provided by the manufacturers of either the process you are using or the tank.

It is often helpful if you start your preparations by standing the solution storage bottles in a large bowl of water at, or perhaps slightly above the temperature you need (assuming that your storage conditions are lower than the operating temperature). You need a supply of hot water for this. In summer, or in the tropics, you may need to cool things down by using iced water baths. If you do this, remember that for quickest cooling there should be plenty of water as well as ice in the bath.

Adding the developer

Before you set out to use your developing tank for the first time, measure out a volume of water equal to what is needed of the processing solutions. Practise adding the water quickly through the central aperture in the tank lid. You should be able to do this as quickly as possible without spilling any. You should also find out how long it

3.7 Temperature control: **A** adjusting the temperature of a measured volume of solution, **B** keeping a developing tank and solution at the correct temperature.

3.8 Use of a developing tank: **A** adding the measured volume of developer, **B** sealing the tank, **C** inversion agitation, **D** rotational agitation.

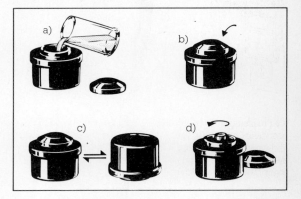

takes to pour out the standard volume of water through the draining aperture(s). This is important, since it forms the last part of any processing step that you carry out and must therefore be counted as part of the required processing time. Thus, if it takes you 15 sec to pour out a developer solution from the tank you must start draining the tank 15 sec before the development time has elapsed.

To start developing, add the developer as quickly as possible, note the time or start the timer, replace any close-fitting lid or cap and immediately agitate the solution. The sequence is shown in fig 3.9.

Agitation

In order to get uniformly developed images, without dark or light patches or streaks, you will have to agitate solutions from time to time. If you do not,

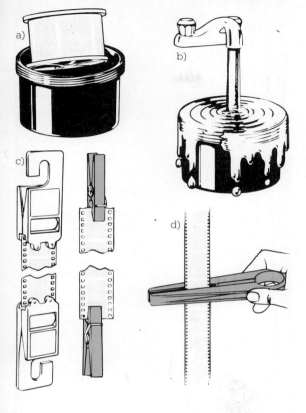

3.9 Final stages in processing: **A** developed and fixed film, **B** washing the film without special equipment, **C** alternative clips for hanging up film – purpose made and clothes pegs, **D** squeegee to remove excess water.

Start agitation immediately after adding a solution, say, with an immediate 10 sec of inversions (from two to four inversions) and follow this with a single inversion and restoration at ½ min intervals during development. The exact details of agitation are usually not very critical as long as you give enough – generally, you should not allow more than 1 min between agitations. Concentrate on achieving consistent agitation so that you can give your films as near as possible identical development each time.

Completing the process

At a pre-determined time before the development is up, pour all the developer out of the tank and into a convenient container. To coincide with the end of development, quickly add the stop solution to the tank and agitate vigorously for 20 seconds. One minute is generally quite sufficient time to stop development and prepare the film for fixing.

Once again, pour out the solution into a suitable container and then add the fixer to the tank. At this stage, provided that you have used a stop solution, you can safely remove the top of the tank and look at what is happening. You normally find that you have developed the required negative images and that most of the film looks milky. As you watch, the milkiness will clear and you should remember the rule of thumb, which is to continue fixing for twice the time needed for the film to clear.

If you allow less than sufficient time for fixing, the processed film may look satisfactory but subsequently fade or discolour in patches and make it impossible for you to get good prints. Agitation during fixing speeds things up, giving you more even fixation and less risk of patchy fading.

It is not a good idea to prolong fixation unduly as the image can become bleached. This is most likely with rapid fixers and fine-grain (slow) films. When you try to print such negatives you will then find that there is a loss of shadow detail.

Washing

Having fixed your film, you must wash it thoroughly to remove unwanted salts. This discourages marks due to crystals forming on the film surface, uneven discoloration and fading of the image and chemical contamination of you, your darkroom and equipment.

You can often wash the film in the spiral, while it is still in the developing tank. Attach a narrow flexible hose to a tap and run water directly down

chemical by-products can build up on the film surface and cause patchy development.

Many developing tanks are designed with an additional sealing cap which you fit after adding a solution. This allows you to agitate the solution very efficiently by inverting the tank rapidly and then turning it back the right way up. After doing this, air bubbles may be trapped within the spiral. Dislodge them by a couple of smart taps of the tank on your work surface. Take care not to hit a plastic tank so hard that you break it.

Alternatively, some tanks are fitted with a device to rotate the spiral so that you can agitate the solution. This may be less efficient than inversion and films sometimes work themselves partly out of spirals when rotated. Given the choice, use inversion agitation. If not, carefully follow the instructions given by the manufacturer of the developing tank.

the centre of the spiral as shown in fig 2.7. It flows back up through the spiral, between the turns of film, and escapes through the vents provided to allow rapid filling or, as shown in fig 3.9, over the edge of the open tank.

If possible, use a water supply at approximately the same temperature as the processing solutions. Very cold or warm water can damage the emulsion by causing reticulation, giving an unwanted texture clearly visible in the prints.

Generally, 30 min washing should be enough for any film provided that a reasonable flow of water is available. If you do not have flowing water then you have to use a different strategy. After fixing, pour the fixer out into a container and rinse the tank with clean water. Discard the rinse and fill the tank with the normal solution volume of clean water. Agitate the tank vigorously for twenty seconds and allow it to stand for a few minutes. You can then pour away the wash water and drain the tank thoroughly.

Add a further volume of clean water and repeat the cycle six times more. This is, in fact, a highly efficient use of water but it does involve more work than using running water.

At the end of washing you should rinse the film in water to which a few drops of wetting-agent have been added, to avoid the formation of drying marks.

If you process sheet film on clip hangers in a three gallon tank line, or a rack of processing spirals in a similar system, you need a wash tank of equivalent size. This is essentially similar to the standard three gallon tank but has a water inlet pipe and distributing system at the bottom. You simply connect the water supply to the inlet and allow the water to pass upwards through the processing racks and overflow into the surrounding sink. This is very similar to the use of the print washing tank shown in fig 2.7. An efficient wash of this type fills in approximately one minute. If the filling takes much longer, a full load of film will not be adequately washed unless you extend this stage considerably. Keep all processing equipment clean and always wash it thoroughly after use.

You should consider the advisability of fitting a proprietary filter to all water supplies used for washing in order to avoid contamination of films and prints by solid particles carried in the water. This is particularly important in film processing because any such particles are inevitably enlarged optically at the printing stage.

Drying the film

Once you have finally rinsed the film the next step is to dry it. To do this, take the film out of the final rinse and hang it up by one end in a suitable area – as dust-free as you can achieve. You will need a clip at the top which you can hook on a horizontal rod or string, and a weighted clip at the bottom to prevent the film curling up and sticking to itself or blowing around and sticking to something else. The emulsion is quite easily damaged when wet, so take care.

At this stage you can carefully wipe the film with a clean proprietary squeegee to remove surface water drops and so speed up drying and help to avoid drying marks. Be careful to use a clean, damp squeegee. If the wiping surfaces are contaminated with grit or lack lubrication by being used dry, you risk making lengthways scratches in the emulsion which can physically remove some of the negative image. This shows up as long dark lines on prints made from the film concerned. It is best to wash a squeegee immediately before and after use, and to keep it clean when not in use. Film clips and squeegees can be bought from your photographic dealer.

Sheet films are dried in their clip hangers. You simply hang them up in a warm, dry and dust-free atmosphere and wait. Usually, in other than small-scale work, these drying conditions are obtained by using a drying cabinet, as illustrated in fig 3.10. If you buy such a drying cabinet make sure that it is tall enough to accept a 36-exposure length of 35mm film and has the necessary supporting points for clip hangers.

For smaller scale work you can gently warm the film to assist drying. But avoid overheating or you may melt the emulsion. A fan heater in the same room (but not directed at the film) is probably as rigorous drying as you should use. If you are desperate to dry a film quickly a hair drier can be used provided that you take great care to keep it moving to avoid overheating and do this in a dust-free environment. On the whole, you will find it much safer to leave the film to dry naturally overnight. Commercial drying cabinets probably provide the best means of drying a film but are expensive if you only need to dry films occasionally.

Spirals and tanks should also be carefully dried. Do not be tempted to overheat plastic processing equipment, or it may distort and prove impossible to use in future. Measures should also be treated with care; you can damage them or make them inaccurate by overheating.

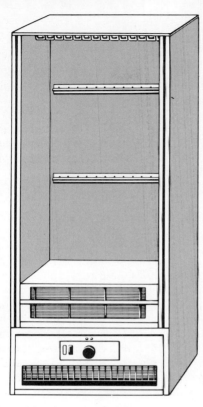

3.10 A drying cabinet for processed film.

Used solutions

In many cases developer solutions have sufficient capacity for you to develop more than one film in the volume you normally use in the spiral tank. It is often possible to keep undiluted developers for reuse, but not when further diluted for special purposes – a procedure discussed later in this book. The instructions supplied with the developer will tell you about this and also about techniques for reuse.

Stop solutions can generally be reused and fixers have a very large capacity for fixing films. Once again, the manufacturer's data provides a good guide. Be prepared to keep solutions, do not automatically throw them down the drain without checking whether you can use them again.

If you do have to throw a solution away make sure that there is a plentiful flow of water to carry chemicals away quickly and dilute them to minimise any adverse effects on the drainage system.

Special considerations in large-scale processing

For small-scale processing you can use fresh solu-

tions each time, or make allowances for previous use when deciding on a development time. This is impractical in large-scale work. One-shot, or discard, processing is inconvenient when handling three gallons of solution and in such cases you chemically replenish solutions to keep their activity constant. Thus consistent development time, temperature and agitation will give you a constant result.

Chemical replenishment is more complicated than you might think. The developer is the most crucial solution and the most awkward to replenish. In use, the developing agent is used up and hence reduced in concentration. At the same time by-products of development, notably bromide salts, build up in solution. Both of these changes adversely affect developer activity and must be compensated for by replenishment if you are to get the results you want.

Unfortunately, you cannot put the solution right simply by adding fresh developer. If you do this you need to replace the solution completely to get the concentration of developing agent right – which, in effect, is discard processing. Addition of a more concentrated solution could correct the concentration of developing agent but would do little or nothing to reduce the concentration of bromide. What the developer manufacturers do is to supply a replenisher solution for a particular developer. The replenisher contains a high concentration of developing agent with sodium sulphite but no potassium bromide. A typical developer and replenisher are shown in fig 3.11. Usually, replenishment of a black-and-white developer is carried out simply by topping-up the solution level using the replenisher solution. This makes good the volume lost through carry-over into the next solution by processed films.

Fixer solutions accumulate silver salts in solution but contain such a high concentration of hypo or equivalent salts that they seldom become unable to clear films. On the other hand the acidity of

3.11 A typical developer and its replenisher. Kodak D-19 and D-19R.

	D-19	D-19R
Metol	2.0g	4.5g
Sodium sulphite (anhydrous)	90.0g	90.0g
Hydroquinone	8.0g	17.5g
Sodium carbonate (anhydrous)	45.0g	45.0g
Sodium hydroxide	–	7.5g
Potassium bromide	5.0g	–
Water to	1.0 litre	1.0 litre

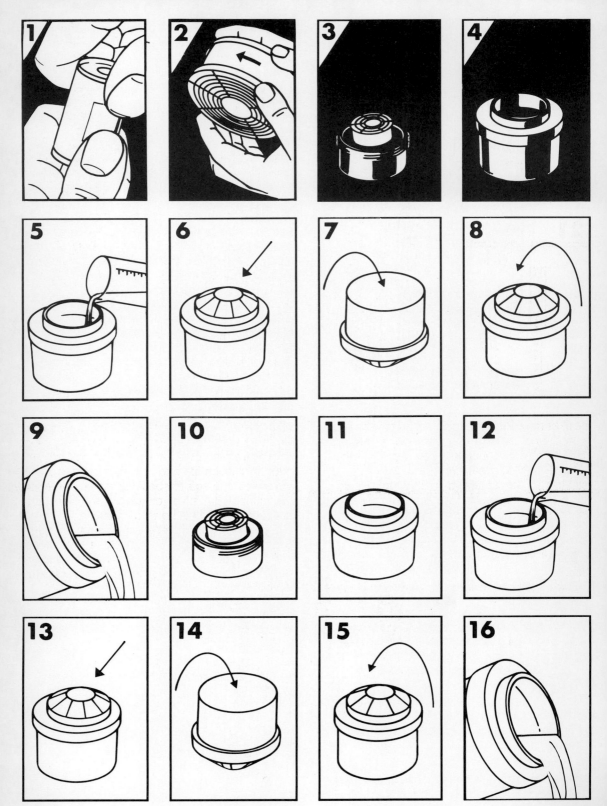

3.12 Developing a black-and-white film. 1, *Lights out.* Open the cassette and remove the film; 2, Load the film into the spiral; 3–4, Place the spiral in the developing tank and close the lid; 5, *Lights on.* Pour in the developer; 6–8, Close the cap of the tank and agitate by inversion; 9, Pour out the solution so that the last drops run out just at the end of the development time; 10–14, Repeat with the stop bath; 15–19, Repeat with the fixer; 20, Wash the film, finishing with dilute wetting agent; 21–22, Hang up the film to dry and squeegee to remove surface water.

the fixer may decrease, particularly if no stop bath is used, and the fixer may become useless if development can continue in it. The build-up of silver salts, if too great, can result in such salts remaining in the emulsion in harmful quantities. Fibre-based papers can also absorb rather large amounts of silver salts from an over-used fixer. If this happens the long-term stability of the developed negative or positive image is likely to be impaired. The effect is similar to that of insufficient fixing.

Fixer solutions in large-scale processing can store up quite large quantities of silver and can be regenerated by removal of the silver using electrolytic silver-recovery units. This procedure both extends solution life and recovers metallic silver which you can sell to specialist refiners. Or you can monitor the silver content of the fixer and, when fully used, sell the entire solution.

Replenishment of processing machines is normally fully automatic. The machine will assess how much material has been processed and replenish the solutions accordingly from reservoirs of replenisher solutions.

4 DEVELOPING BLACK-AND-WHITE PRINTS

9 Print developers are specially formulated to give good contrast with rich blacks and clean whites – an important feature of the tonal values in this photograph.

Developers for printing papers

When you develop prints you need a high-contrast image which is free from objectionable fog and is obtained quickly. The developer is therefore usually of a type designed to be both active, to give high contrast and short development times, and well restrained, to prevent development of unexposed emulsion. Such developers are commonly made up and stored as a concentrated 'stock' solution which you dilute for use. As in the case of negative developers, the stock solution is usually quite stable when stored. The diluted 'working' solution is not, and is discarded after use. Dish processing, because of the large surface of solution exposed to the air, is not in any case conducive to developer stability.

A formula for a typical print developer is given in fig 4.1. Notice that, compared with the negative developer shown in fig 1.4, the print developer has a higher ratio of hydroquinone to metol. This tends to give a high contrast, or 'harder', image and is assisted by the bromide content which also restrains fog formation. D-163 has a low metol concentration and a lower accelerator concentration than the Du Pont 53D.

4.1 A typical print developer. Kodak D-163.

	Stock solution	Working solution
Metol	2.2g	0.55g
Sodium sulphite (anhydrous)	75g	18.75g
Hydroquinone	17g	4.25g
Sodium carbonate (anhydrous)	65g	16.25g
Potassium bromide	2.8g	0.7g
Water to	1 litre	1 litre

For use, one part of the stock solution is diluted with three parts of water.

The other processing solutions required for print developing are not very different from those used for negative films. It is a little more important to use a hardening fixer for prints because they are quite often dried at higher temperatures than films.

Getting ready

When you set out to print your developed film you will need the items described in Chapter 2. As with film developing, you must first read carefully

any processing data supplied by the manufacturer of the printing paper. Then, check that you have everything you need and that it is all laid out for ease of working. In particular, you must arrange the solutions, in dishes (each at least 25mm (1in) bigger than the paper in each dimension) in the order: developer, stop, fixer and final wash, as shown in fig 4.2. Be sure that you know which is which. You may find it useful to have dishes labelled, or of different colours. You can use a safelight while printing so that you can see the dishes quite clearly. Make sure that the safelight filter is appropriate to the paper you plan to use.

Solutions should be at 20°C (68°F) if you have treated the storage bottles as suggested for film processing in Chapter 3. If they are not at 20°C you can adjust temperatures as shown in fig 3.7 before pouring in the solution. If the solutions are already in the dishes then those dishes can be placed in warmer or colder water, as required. You will not find it easy to keep dishes at very different temperatures from that of the room in which you are working, so try to adjust that first.

You should put at least 2cm (¾in) of solution

into each dish to ensure evenness of development and the other processing procedures. Do not, on the other hand, over-fill dishes or you will lose solutions when you agitate. It is quite common for some prints to be left together for a while in the fixer. For this it is useful to have an extra large dish. A dish used for washing should also be considerably larger than the developing dish because you will collect quite a number of prints in it as printing continues. (Note the darkroom guide to processing prints, fig 4.5, at the end of this chapter.)

Seeing what develops
To process an exposed sheet of paper slide it, emulsion (creamy-coloured side) down, into the developer as shown in fig 4.3A. Note the immersion time and rock the dish, gently and continuously, from side-to-side and end-to-end as shown in fig 4.3B. Continue this until 10 sec before

4.2 A bird's-eye view of a darkroom bench laid out for black-and-white print processing. Print forceps are positioned beside each processing dish and a wall-mounted safelight illuminates the bench.

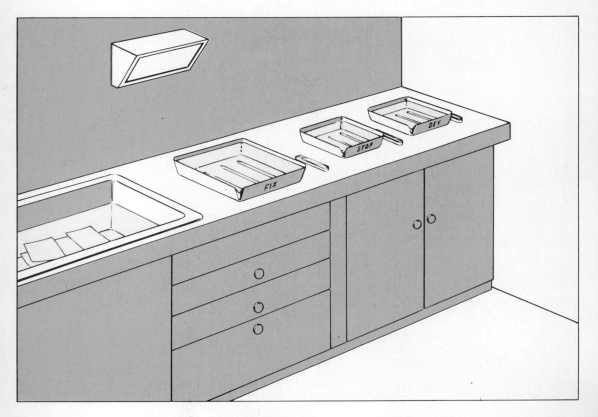

4.3 Steps in developing a print: **A** sliding the exposed paper into the developing dish below the solution surface, **B** agitation by tilting and rocking the dish, **C** removing and draining the print using forceps.

completion of the recommended development time. Drain for 10 sec and transfer the print to the next solution. Note that after about 30 sec in the developer you can turn the print face up and have the thrill of watching the image develop before your very eyes. If you do this, make sure that your agitation gives a flow of developer across the print surface and that the print is not too close to the liquid surface to be properly developed.

The development time specified by the paper manufacturer should be adhered to unless there is no recommendation. If so, then use a time of 2½ min at 20°C – fairly average for printing paper. Try to be as consistent as possible and hence use standardised time, temperature and agitation during development and other process stages.

10 Dr Barnes Wallis in his garden. As in the development of films you must give good agitation to avoid a streaky appearance in areas of near-uniform tone, such as blue skies.

Stop and fix

Ten seconds before development ends lift the print out of the dish by one corner (fig 4.3C) and allow it to drain into the dish. Then, transfer the paper to the stop solution. Some workers use a water rinse but if you use a special stop solution you will halt development more precisely, minimise the risk of staining, cut down contamination and increase the useful life of the fixer.

Agitate the print in the stop bath continuously and remove and drain the print after about 30 sec (the time is not critical here). Then, immerse the print in the fixer, face down, and stir it around to ensure that no air bubbles are adhering to the emulsion. If you wish, you may then turn the print over and inspect the developed image while fixing continues. As long as the print is not floating at the solution surface you need not agitate it much in the fixer (but make sure that it does not stick to any other print while it is there).

Fix the print for the recommended time, but if you have no other instructions then 10 min should be adopted as the minimum fixing time at 20°C. You need not rush to lift prints out at exactly the stipulated time but prolonged fixing should be avoided because of the risk of bleaching, particularly with rapid fixers. Prolonged fixation of printing paper can also make the final wash stage more difficult to carry out properly.

Washing the prints

The final processing step is to wash the developed prints thoroughly in running water using equipment such as that described in Chapter 2 and illustrated in fig 2.7. Unless there are instructions to the contrary, you should wash prints for at least 30 min, keeping an eye on what is happening and separating any prints which show signs of sticking together. Increasing the wash time by up to 100 per cent will do no harm and can increase stability of the processed image.

Drying and glazing

You can dry your prints simply by wiping off excess surface water and hanging them up in clips, (fig 2.8C) to dry naturally or you can speed things up by gentle heating (fig 3.10). Alternatively, place them face down on special photographic blotting paper. You can achieve quicker drying and, if required with glossy paper, a glazed surface, by using a flat-bed glazer. This clamps the print against a heated surface which is very hard and shiny. For really large-scale work rotary

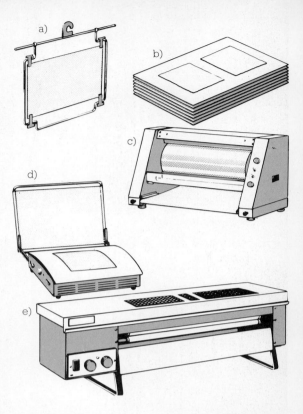

4.4 Drying prints: **A** clip hanger with print drying naturally, **B** prints are placed face down on special blotting paper and are left to dry; more than one layer can be stacked to save space, **C** a flat-bed glazer can be used to glaze a few prints at a time, **D** rotary glazers have the highest throughput of prints, **E** radiant drier for resin-coated paper.

glazers may be used. These operate continuously rather than in the batches that flat-bed methods can cope with. Drying and glazing methods are shown in fig 4.4.

Resin-coated papers

All the details of print processing described so far apply to traditional bromide 'fibre-based' printing paper. In recent years 'resin-coated' (RC) paper has become increasingly popular. The paper base is laminated with polyethylene on both sides and is thus waterproof. The emulsion is coated on the surface of the lamination, rather as on a film base. This base does not absorb significant amounts of chemicals from the processing solutions and as a consequence developing procedures differ quite significantly from those for fibre-based papers.

If you use this type of printing paper you will

11 Adequate time and agitation at the stop and fixing stages in developing prints avoids staining of the highlights or streaks. Even if not immediately obvious, such faults can materialise over a period of time and would be most apparent in pictures with large areas of highlight or pale tone.

12 As well as stained highlights, inadequate washing of prints can cause bleaching in shadow areas after a period of time. Such effects would ruin an image which depends largely on these tones for its effect. This print on fibre-based paper, was given the long wash required for such products.

find a number of differences compared with the traditional materials:

1 Special processing solutions may be recommended. If so, you will probably get the best results by using them. Ordinary traditional print processing solutions will, however, work quite well.

2 Processing times will be shorter if the recommended solutions are used.

3 Wash times can be drastically reduced because chemicals do not penetrate the resin-coated paper base. Two minutes may be quite adequate as a final wash for resin-coated papers.

4 Print corners can be sharp. Take care to prevent one print from damaging another during processing.

5 Prints dry quickly and no glazing is required for glossy surfaces. Do not use a flat-bed or rotary drier or glazer, or you will probably melt the polyethylene laminate and ruin the prints. Special radiant drying machines are made for use with resin-coated papers (fig 4.4).

Clearing up

When you have finished printing, wash all the measures, dishes and other utensils you have used. Discard the print developer, which cannot generally be used again. Also discard the stop bath even if it is not exhausted. This is, anyway, cheap to replace. In many cases, however, you will be able to keep the fixer and use it again another day. Most manufacturers tell you how many prints of a given size can be fixed by a particular volume of solution. You can save money by

13 Weaver. The convenience of resin-coated printing papers makes them ideal for news and feature work where pictures may be needed in a hurry but are not intended for archival storage, or the ultimate in fine printing.

using fixer fully, but try not to exceed the recommended loading or you may find your prints becoming stained or discoloured on storage, or even during drying.

Hazards and precautions

You should treat photographic chemicals with respect. Some are harmful to your skin, most are harmful if you swallow them or get them in your eyes. Some will stain your skin or your clothing if prolonged contact is allowed. In order to avoid such problems, take care to avoid spillage and contamination of work surfaces, wash all utensils thoroughly immediately after use, wear overalls, use protective gloves and, ideally, wear protective glasses when mixing chemicals. If, despite your care, contamination does occur, wash the area with large quantities of water. If your eyes are affected, flood them with running water immediately to remove the chemical(s), then seek medical aid. If you swallow chemicals get immediate medical attention. Chemical solutions are also corrosive. Keep all equipment free from spilt or residual chemicals.

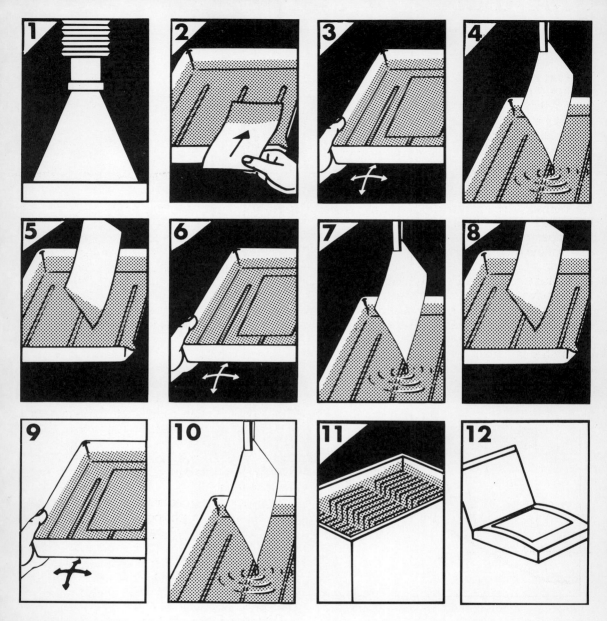

4.5 Developing a black-and-white print. 1, Lights out; expose the print; 2, Slide the print into the developer; 3, Agitate the developer; 4, Remove the print from the solution and drain off the liquid up to the development time;

5–7, Immerse the print in the stop-bath and continue as for the developer; 8–10, Repeat the treatment with the fixer. You can use full lighting if you wish after about 30 seconds; 11, Wash the print thoroughly; 12, Dry the print.

5 MEASURES OF THE IMAGE

If the test of success in photography is the finished product, it is also the point at which some results that fall short of expectations first become apparent – for a variety of reasons.

To obtain exactness in describing qualities of photographs it helps to know and be able to use the language, or jargon, that has grown up in photographic science. This will also help you to understand the more useful articles that appear in the journals. This chapter describes and shows how to assess the way the various tones of the subject appear in the picture – the broad effect – and also matters to do with fine detail.

Recording tones – the characteristic curve

In a negative the lightest parts of the subject register as dark areas, and vice versa. The relationship between the subject tones and the amount of developed image in the negative is shown in fig 5.1 as a rather important graph – the *characteristic curve* of the photographic film used. Curves of this type are very widely used in the literature so it is worthwhile learning about them.

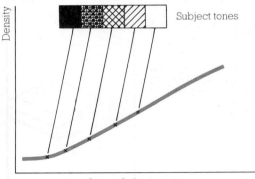

5.1 The photographic characteristic curve related to the tones of a simple subject. The darkest parts of the subject are imaged with low density while the lightest parts of the subject give the highest densities found in the negative.

The vertical scale of the graph shows a measurement of the amount of image developed. This measure, *density* tallies very closely with our impression of blackness. For readers with a scientific background: density is defined by

$$D = \log_{10} \frac{I_o}{I_t}$$

where I_o is the intensity of the light striking the image while I_t is the intensity of the light passing through. If only one-tenth of the light passes through we have

$$D = \log_{10} \frac{I_o}{0.1 I_o} = \log_{10} \frac{10 I_o}{I_o}$$

ie: $D = \log_{10}(10) = 1.0$

If you have not used logarithms, or are not interested, you can simply regard density as describing the degree of blackness of an image. It is measured using an instrument known as a densitometer in which light is shone through the sample to be measured and on to a sensor. The resulting measurement of density is displayed on a suitably scaled meter or a digital readout device. The horizontal scale of the characteristic curve shows a logarithmic measure of exposure – usually shown as \log_{10} of the relative exposure. This means that if one exposure level is ten times that of a second, the two are separated by 1.0 units horizontally – along the log relative exposure axis. The log of the relative exposure varies with the appearance of brightness of the subject. In an average scene the lightest area is likely to be about 150 times the brightness of the darkest shadow area. This corresponds to a log exposure range of about 2.2.

Fig 5.1 shows the characteristic curve of a negative film. Different photographic materials may have quite different characteristic curves. Some examples are shown in fig 5.2 and you will see straight away that the curves differ in several ways that are easily understood. The important features of characteristic curves can be summed up in a few useful measures – or *parameters*.

Film speed has to do with how little exposure is required to get a useful record of the subject. Thus, in fig 5.2A you will see that film 1 needs less exposure than film 2 and can therefore be described as a *faster* film. The horizontal separation of the curves shows the logarithmic difference in speed between the films. A separation of 0.3 would mean that film 1 has twice the (arithmetic) ISO or ASA speed rating of film 2, or 3 units difference on DIN in other logarithmic speed systems.

The term *contrast* is often used to describe the steepness of the relationship between the de-

veloped density and the subject tones – that is, the steepness of the characteristic curve. This is traditionally measured, as shown in fig 5.3, on the central straight-line portion of the curve.

Two other, rather simple, parameters complete the basic description of the curves. These are the minimum and maximum densities which can be obtained from the combination of film (or paper) and developer used and are of particular importance in positive records such as reversal transparency films and all printing papers and films.

Modern photographic materials often do not have much of a straight line portion in their characteristic curves and you will find other measures of contrast used than simply the slope of that portion, usually designated by the Greek letter gamma (γ). In particular, you will probably read of \bar{G}, (used by Ilford Ltd) and pronounced 'gee bar', and Contrast Index, or CI (used by Kodak). Both are measures of average slope from the lowest useful density on the curve to a density typical of the record of a subject highlight. For all contrast measurements, the higher the figure the steeper the curve measured. You are probably familiar with the contrast control on a television set. An increase in contrast for a monochrome picture leads to a rather black and white image – a 'soot-and-whitewash' effect – while a decrease in contrast is seen to give very grey results. The same is true for photographs.

14 In this study, the importance of tone control is obvious in clearly showing the shape and form of the bottles and the arrangement within the frame. This requires careful development and printing, in this case using a high quality exhibition paper for maximum tonal range.

a) Negative films

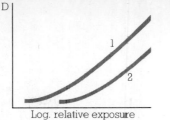

b) Printing paper

c) High-contrast (lith) film

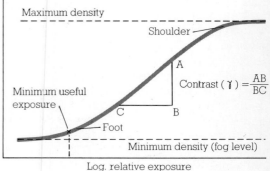

Maximum density

Shoulder

A

$$\text{Contrast } (\gamma) = \frac{AB}{BC}$$

Minimum useful exposure

C B

Foot

Minimum density (fog level)

Log. relative exposure

5.2 Characteristic curves of photographic materials. The log exposure scales are relative and no comparisons of photographic speed should be made except for curves 1 and 2 in A.

5.3 Terminology of the photographic characteristic curve. Sometimes the curve is referred to as an H & D curve after Hurter and Driffield, pioneers in photographic science, who first used such graphs.

15 Most of the interest in this photograph depends on the mid-tones, recorded some way up the negative characteristic curve. The two, very dark, posts were recorded near the foot of that curve and the lightest reflections from the water surface are relatively high on it.

Control of the characteristic curve

The curves illustrated and discussed above are not really a fixed property of the film. You can often control the curve to some extent by your development conditions, particularly with black-and-white negatives. Increasing the development time then leads to an increase in contrast accompanied by some increase in effective speed.

Black-and-white printing paper behaves rather differently. Provided that you start with a normal development time there is little change in curve shape if the development is extended. The contrast (slope of the characteristic curve) scarcely changes but the effective speed increases – sometimes by enough to enable you to rescue an otherwise slightly underexposed print.

The control of negative contrast is particularly important as it governs the density range of the negative and this affects your chances of obtaining good prints. Film manufacturers, for example, may specify two different development times for a film depending on whether a condenser or a diffuser enlarger is to be used for printing the negatives obtained (the former emphasises photographic contrast while the latter attenuates it). There may also be a corresponding effect on the effective film speed.

You should therefore aim to discover the most suitable development time for negatives, at a constant temperature, for your printing conditions, and to use it consistently as a standard. It will then be easier to obtain the best results and you need depart from your standard methods only when necessary, perhaps to save an underexposed film or print. This is the subject of chapter 8.

Fine detail

If you look closely at photographs you become aware of properties of the image which are much smaller in scale than tonal relationships such as contrast. Large areas of uniform greys look less even when you get closer or increase the magnification. They appear 'mealy' in nature, a characteristic usually termed *graininess*. Fine detail may be partly broken up by graininess but will, in any case, be reduced in contrast and visibility in the photograph by the scattering property of the photographic emulsion, during exposure.

Graininess and granularity

The grainy appearance of a black-and-white print is shown in fig 5.4, in which a series of differently

5.4 Prints made from the same negative on the same grade of printing paper, but at 5x, 10x and 20x magnification. The film was Ilford HP5 rated at ISO 400/27° (ASA 400/27). and developed in ID-11.

magnified images is displayed. You will notice that lightish tones have a more grainy appearance than darker greys, while large image areas appear more grainy than small. If you include much fine detail, your photographs look less grainy than if only a few large areas of nearly uniform tone are present.

Graininess is essentially something that you perceive. It depends on many factors which are associated with the viewing conditions as well as the image being examined. The graininess of a negative is of very little importance, but the graininess of a print is something which can enhance or, more often, detract from its general appearance. The instrumental measurement of the mealy appearance of an image is termed *granularity*. By

16 This photograph, taken with a rather grainy film, shows in the original an absence of graininess in highlight and shadow but a good deal in light grey areas of clouds and the façade of the buildings.

17 The structure of the image itself makes the effects of grain immaterial, even with a 20x diam. enlargement.

using an instrument known as a microdensitometer the density of a very small area of a uniformly exposed and processed film can be measured. Such measurements, drawn on a graph to show the variation of density as you move across the image, can be used to calculate a numerical value for granularity. The value obtained depends on the area of the measuring aperture of the micro-densitometer so this should usually be specified and is typically some 25 x 25 micrometres. Examples of such plots of density against distance across the image are shown in fig 5.5 and represent equal density levels for three different films – one coarse, one medium and one fine-grained. It will be obvious that the graphs show that the density varies about some average level and that the spread is much greater for the coarse than for the fine-grained film.

Because a printing paper is not liable to the same subjective effects as the human observer it is the negative granularity which is transferred at the printing stage and which governs the granularity of the final record. The graininess of a negative is therefore of little significance.

While our perception of graininess shows a maximum at fairly low image densities the same is not true of granularity. This is generally found to

increase with density for silver images of the type conventionally developed with black-and-white films. Since it is the negative granularity which is transferred to the print it follows that for minimum graininess in that print you should be careful not to overexpose or overdevelop the negative.

Sharpness and acutance

Photographers are, rightly, sensitive to the *sharpness* of their pictures. If you were to be given a series of prints to look at you could probably sort them into an order of sharpness from the worst to the best. You could probably reshuffle them and then repeat the previous exercise exactly. Yet you probably could not put a number to the sharpness of any print – other than an indicator of the position in your order of ranking. There is no simple measurement that can be made to evaluate sharpness.

Photographic scientists, faced with a need to

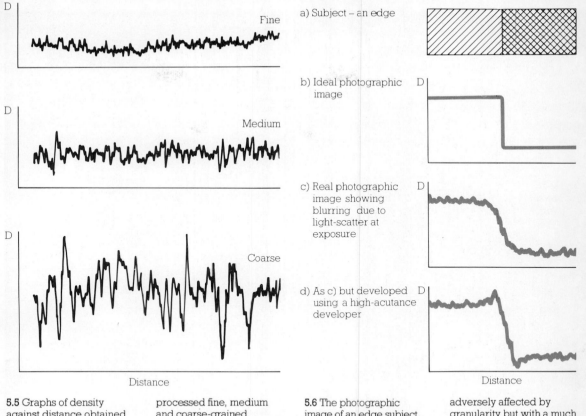

5.5 Graphs of density against distance obtained by scanning with a microdensitometer samples of uniformly exposed and processed fine, medium and coarse-grained emulsions, all developed to the same image density.

5.6 The photographic image of an edge subject. The developed image C shows the effects of light-scatter during exposure and granularity. The use of a high acutance developer D shows the image still adversely affected by granularity but with a much improved rendering of the sharp edge. The image developed in D shows a higher acutance than that in C.

express sharpness quantitatively, have investigated a number of types of image. The most useful test turns out to be the record of a definite sharp edge between one tone and another. The developed image is measured using a microdensitometer and the resulting edge trace is analysed mathematically to evaluate *acutance* – a measurable quantity that agrees well with the perceived sharpness.

Acutance has to do with the steepness of the edge trace. Steeper edges look sharper and give higher values of acutance. Steepness is measured in a special way that is beyond the scope of this discussion. The term acutance is, however, often used to denote a particular type of developer which exploits a sometimes useful distortion of the edge profile. Fig 5.6 illustrates the enhancement of edge contrast obtained using the appropriate developer.

Further attention will be paid to the question of sharpness, and how to improve it, in Chapter 10.

Resolution

A traditional measure of quality that you will find widely used is the *resolution* or *resolving power* of a lens or film, or the combination of both. It is obtained by imaging a test object of dark lines on a lighter background or vice versa. The lines and spaces are usually of equal width and arranged in a formal pattern as a test chart. A typical example is shown in fig 5.7 and another forms part of the test subject shown in fig 5.4. The image is viewed and the highest number of lines per mm that can be distinguished is decided by visual inspection (often with the aid of a microscope). The figure obtained is the resolving power of the system and represents the limit of fine-detail rendition. It tells you nothing at all about how well the system records intermediate detail between fine and coarse.

A rule of thumb (and that is all that it is) can be

5.7 A typical resolution test chart.

used as a very rough guide to the resolution you can expect from a camera and film in combination. What you do is to work out the reciprocal of the resolution of the camera and add it to the reciprocal of the resolution of the combination. This may be written

$$\frac{1}{R_{combination}} = \frac{1}{R_{camera}} + \frac{1}{R_{film}}$$

Hence, if the lens resolves 80 lines per mm and

18 By contrast with picture 20, this architectural study calls for maximum resolution. Only the best technical quality will do.

the film 60 lines per mm, the overall system resolution is calculated to be about 35 lines per mm. The important point to note is that this shows the combination to have a rather lower overall performance than you might expect. The calculated figure is unlikely to be a good predictor of system performance because the method of calculation is at best approximate.

When you investigate the resolution of a film you find that it depends on the exposure level, generally peaking at a lowish exposure. It also depends on the contrast of the test chart used, contrast here being defined as the lightness difference between lines and spaces. Black lines on a white ground, or the opposite configuration, give a higher value for resolution than grey lines on a different grey background. You will find a set of curves describing these variations in fig 5.8 which also shows the characteristic curve of the film. Clearly, it is important to use the lower part of

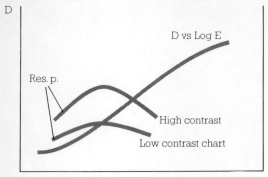

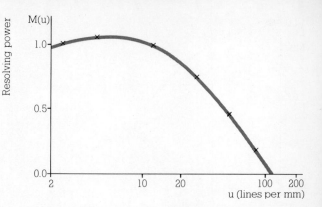

5.8 The variation of resolving power with exposure level and with chart contrast. It will be seen that the resolution reaches a maximum value at rather low density levels and that high contrast subjects are better resolved than low.

5.9 The modulation transfer function (MTF) of a typical photographic emulsion and developer combination. The line frequency axis is often shown with this type of logarithmic scale.

the curve – you should neither over- nor under-expose your photographs if you want the best resolving power.

It is worth, at this stage, considering the philosophy of resolving power as a useful measure of photographic performance. The test charts are linear geometrical arrays and are usually photographed in the centre of the image field. If you actually want to take photographs of linear subjects then resolving-power information may be helpful in optimising your system. For other types of subject such measurements may be less useful to you and practical trials of your own will be necessary.

Modulation transfer function (MTF)

A concept rather like resolution but extending over all line frequencies is that of *modulation transfer*. All you need to know about this is that modulation is a relative measure of contrast, similar to density difference, in an image and that transfer refers to any imaging step. The *modulation transfer factor* at any line frequency, or *spatial* frequency, tells you how much of the contrast survives the imaging step. So, if you have an image formed by a camera lens at, say, 50 lines per mm on a film surface and the film defocuses the optical image by scatter of light within the emulsion, then the modulation of that image is reduced to some fraction of the input modulation.

If the fraction

$$\frac{\text{output modulation}}{\text{input modulation}}$$

is measured to be 0.5 then that is the value of the modulation transfer factor at 50 lines per mm. Similarly, values may be found at any frequencies of interest. A graph of these values as a function of the line frequency is shown in fig 5.9 which shows the modulation transfer factors at a number of spatial frequencies. The smooth curve drawn through these points is the *modulation transfer function* (MTF), and for photographic emulsions is made relative to a value of 1.0 at zero frequency. (In effect, it is divided by the gamma of the emulsion.)

You will frequently find information about lenses and films published in a form similar to that shown in fig 5.9. It is therefore useful to have some appreciation of what such curves mean. The system shown in fig 5.9 fails to have any modulation transfer at frequencies above 110 lines per mm. This means that the resolution limit will be slightly below 110 lines per mm at whatever threshold value of modulation the eye needs to perceive the image.

This can be in the range 0.05 to 0.10, so the resolution will be about 100 lines per mm.

The MTF becomes more useful when you compare optical systems. Consider the examples shown in fig 5.10 in which rather different MTFs are found for two imaging systems. If you were mostly interested in the frequency range 0 to 80 lines per mm, then System 1 would be more useful to you, despite a resolving power lower than that of System 2 which comes to the fore only at the higher frequencies from 80 to 125 lines per mm. In this case, you can clearly get more useful informa-

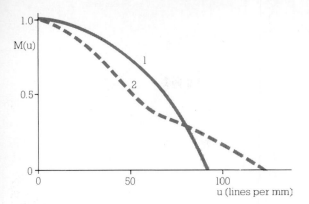

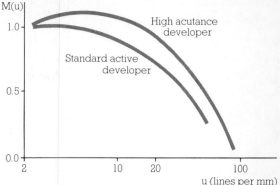

5.10 MTFs of two imaging systems compared. System 1 is clearly more useful at low frequencies while System 2 is better at high frequencies.

5.11 The influence of developer type on measured MTF. The high acutance developer gives considerable enhancement of response in the range 0 to 25 lines per mm and, in this example, appears better at all spatial frequencies.

tion from the MTF than the resolving power.

You will also find MTFs published for various combinations of films and developers. In some cases such curves have strange features which you may need to interpret. Fig 5.11 illustrates the MTFs measured from a single film developed in two types of developer – a very active developer and a high acutance type. You will see that the film gives a generally higher MTF with the high acutance developer. Moreover, for a range of frequencies from 0 to 25 lines per mm, far from defocusing the image formed by the camera lens, the film appears to improve it when the high acutance developer is used. This is, in fact, the result of chemical effects and will be explained in Chapter 10. It is not a simple optical effect and represents a distortion which should lead to care in the use of MTF information. Such measurements are, however, commonly published by the manufacturers and you should know how to interpret them. The high acutance developer gives a better visual sharpness than the more active type and this is achieved by special chemical means.

Whereas the calculation of resolving power for a combination of film and camera lens from information about the components was stated to be, at best, approximate and usually no better than a rough guide, MTF prediction is a much more accurate procedure. Use is made of a very convenient property in the *cascading* of MTFs. At any frequency the effect of combining optical components such as a camera lens and a film can be expressed as the product of the modulation transfer factors, which yields the modulation transfer factor of the combination. This can be written as

$$M(u)_{combination} = M(u)_{lens} \times M(u)_{film}$$

where u represents any chosen frequency. If this calculation is carried out at a range of values of u, a resulting MTF can be drawn. The overall effect is illustrated in fig 5.12. The cascading of MTFs in this way is only strictly valid in the absence of development effects of the type shown in fig 5.11 for the high acutance developer.

Speed, grain and efficiency
Even for the best black-and-white negative films there is a clear link between speed and grain. Generally, faster films give grainier images than slow films and this is, in turn, related to the grain sizes used in the emulsions. Similarly, the coarser-grained fast emulsions are normally less able to give sharp images than slow examples. High speed involves a loss of other desirable qualities.

When you try to look at detail at the limit of resolution in a photograph you find yourself searching the magnified field for something regular – the image detail – which is surrounded by, or immersed in, a sea of random grains. Photographic scientists have borrowed some technical terms, which are more familiar in a hi-fi context, to describe such problems of limiting performance. They view the required image as the *signal* and the surrounding granularity as the *noise* in the system.

An obvious concept then arises to describe an important quality of an image as the ratio $\frac{signal}{noise}$

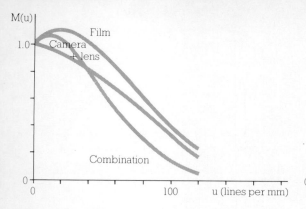

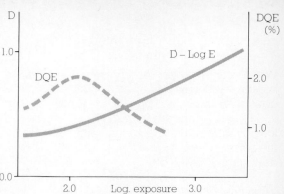

5.12 The cascading of MTFs. In this case the film shows significant edge effects which distort the MTF measured and make the cascading operation less than rigorous. The description of the overall system shown as 'combination' does, however, have an observed enhancement of the low-frequency performance and is a useful indication of what to expect – particularly if the subjects to be photographed are at all like the MTF test material, often edges or resolution test charts.

5.13 The detective quantum efficiency is shown varying with log exposure. The characteristic curve of the film in question is also shown and it is seen that the DQE is highest towards the foot of the characteristic where exposure is low, as is the developed density.

The higher the value of the signal-to-noise ratio, the easier it is for you to detect the signal and the more free from grain the image appears.

In practice, the input signal which the film receives also has some associated noise, although not very much. It becomes useful then to consider the relationship between the input and output signal-to-noise ratios and this is formalised in the Detective Quantum Efficiency (DQE) which you will find mentioned in some of the literature.

In order that you should have some conception of what is being written about in magazines the DQE is defined here as

$$DQE = \frac{(S/N)^2_{out}}{(S/N)^2_{in}} \times 100 \text{ per cent.}$$

It is obviously not necessary to know about this in order to develop and print your photographs! On the other hand, it is of interest to note the behaviour of DQE as a function of exposure and this is illustrated for a typical film in fig 5.13. You will see that lowish exposure levels are needed to get the best DQE but that, even then, a figure of only about 2.0 per cent is achieved. It is this dismally low figure that attracts the attention of supporters of electronic imaging systems which can yield considerably higher values of DQE.

It is probably true to say that the photographers who show the greatest interest in the DQE of films and plates are actually astronomers. They spend a lot of time trying to detect very small and faint images of stars in a background of granularity and are therefore very concerned to optimise the detection. This is achieved by optimising the DQE.

6 THE CORRECT DEVELOPER

When you have selected and exposed a film, or bought some printing paper, you will also need a developer (and other processing solutions). Stop and fixer solutions are not usually very critical so long as they work. The real problem is choosing the correct developer. There is, after all, a bewildering range available.

What type of developer?

Developing solutions which you may read about or find in the shops are usually identified by a generic name such as: general purpose, fine grain, high speed, high definition, high contrast and so forth. You will find more details about the special properties of such solutions in Chapters 7 to 11 and also Chapter 14. It is sufficient to note here that these names are traditional and that some developers designated as 'fine grain', and causing no speed loss, have become 'general purpose' developers suitable for most purposes with the small-format films of today.

The selection of developer type must depend on your needs and the later chapters should give you some ideas as to the types to buy. There are, however, a few considerations you should bear in mind.

Convenience

Once you have decided on a type of developer you will need to find out what particular brands are available from your photographic suppliers. You should also note the solution volumes involved and the form of the developer which is offered to you. Unless you have a need for large-scale processing, the making up and storage of large-volume kits is just not worth while. Fifteen litres of developer can process an immense number of films and may deteriorate from atmospheric or other effects long before being used up photographically. On the other hand, you should not be put off by a large made-up volume if the developer is provided as a concentrated solution of small bulk. Fractions of such developers can be very simply measured out and diluted for use. Powder packs cannot, and should only be made up in one single operation. Because they may not have been fully mixed up before packaging you cannot be certain of making up fractions of the bulk pack to give solutions of the right composition.

Applicability

It is useful if you find the type of developer that you want in a suitable package size and form. It is also useful, if you buy such a developer, if instructions are available for developing the films which you like to use. The developer must be suitable for your films and you can save time and trouble by looking up the recommended developing conditions.

It is commonly the case that a developer made by a film manufacturer will only be accompanied by instructions for developing films made by the same manufacturer. It need not put you off if you already have the developer but circumstances may cause you to buy a batch of some other firm's film. If you cannot find any advice on the developer and film combination, what you have to do is to carry out your own photographic test. The popular photographic magazines commonly carry articles listing such combinations.

Perhaps you already have negatives which you know can give good-quality prints. These can form a reference for experiments with the new and unknown film X (or for the standard film developed in an unknown solution Y). As a rough guide to development you can look up the times recommended for films of similar speed to X. Average these by adding them all together and dividing by the number of films listed. This is your first estimate of the 'correct' development for film X. If you only have one or two films then that estimate is probably the best you can do.

If you have a large number of such films then a photographic test becomes worth while. Shoot a complete film from your batch of X using a single, standard subject and lighting. The subject should preferably be one which you have already photographed using your normal film. It is useful to bracket the indicated normal exposure for X by one and two stops in each direction (over- and underexposure). Thus, the exposed material will have sequences of five frames' length all along the film and each sequence will have five different speed ratings in it. A typical set of such negatives is shown in fig 6.1.

When you develop the film you should cut it, as nearly as possible, into sections five frames long and develop each section for a different time. Make sure that your development time series is centred approximately on the estimated 'correct'

19 A general-purpose developer with conventional film will give you a full range of tones in a negative, which you should then be able to print satisfactorily on grades 2 or 3 paper. This negative was made using Kodak Tri-X film rated at ISO 400/27° and was printed on grade 3 Agfa PE printing paper.

6.1 A typical exposure test series forming part of an experiment to optimise exposure and development conditions for a film-and-developer combination for which there is no available data. The rated film speeds for the frames were as follows:

Frame	8	ISO 50/18° (ASA 50/18° DIN)
	9	100/21° (ASA 100/21° DIN)
	10	200/24° (ASA 200/24° DIN)
	11	400/27° (ASA 400/27° DIN)
	12	800/30° (ASA 800/30° DIN)

Frame 10 was judged to have been optimally exposed and the recommended speed rating for the film (given 11 min processing) *in the developer concerned* was therefore 200 ASA.

development time. A typical series, centred on 8 min, might comprise 4, 5.6, 8, 11 and 16 min. There are good reasons for using times spaced like this and you can, of course, read such a series off the aperture ring of many camera lenses. It is the same logarithmic series as that for the standard lens apertures.

After processing the strips of film try to find the negative closest in appearance to those that you already know will print satisfactorily. It is most helpful at this stage if, in your test exposures, you have duplicated a photograph that you have already taken on your normal film. When you have found the frame which best matches your standard photography you should record the effective speed of X and the required development conditions.

You should then print your selected negatives from X and from the film that you already know

6.2 Optimisation of a developer-and-film combination – comparison of prints: A print made from a standard film on grade 2 paper, A, is compared with a print made from the unknown film X processed in the standard developer and rated at ISO 200/24°. X is also printed on grade 2 paper, B, and the results are compared. You will see that print B looks slightly lower in contrast, is grainier and less sharp than A.

A

B

about. If the prints match reasonably well then you can go on to use film X with confidence. The print comparison is illustrated in fig 6.2.

One particular practical point should be noted, however. Ilford ID-11 and Kodak D-76 developers, for example, have the same composition and are in every way equivalent in performance. Other identical pairs of developers do, no doubt, exist. A chat with your photographic dealer might reveal such equivalent products and save you a lot of time and effort especially if you already possess an equivalent developer to that recommended for film X. Or, you may have special requirements governing the choice of developer.

Working life
Some developers, once mixed, possess a rather short life. Others, especially concentrated liquids, have very long storage lives which make them useful if needed only occasionally. Some well-known standard developers supplied as powder kits have good storage properties in the standard made-up volume. If, for special purposes such as gaining high definition or economy, you wish to use the solution in a dilute form you should dilute the stock solution immediately before use only, and then, because it is unlikely to keep, discard the diluted solution after use.

A few special-purpose high contrast developers are made up as two stable solutions which are mixed in equal proportions just before use and are discarded afterwards. Single-solution developers designed to give similar results should be checked with care; you may find that they too have rather short useful lives.

Assessing the results
If you have no good reason to do anything else, you should use a convenient general-purpose developer. This is very likely to suit all the negative films you use and may be of a type suitable for printing papers as well. A different dilution will generally be needed in each case. Two typical formulae for such developers are shown in fig 6.3 and are often called 'universal' developers. Such convenient solutions do not usually get the best from your materials in any one attribute but give you good, usable negatives and prints. It is probably only worth looking for something special if you cannot get the results you need from a universal developer.

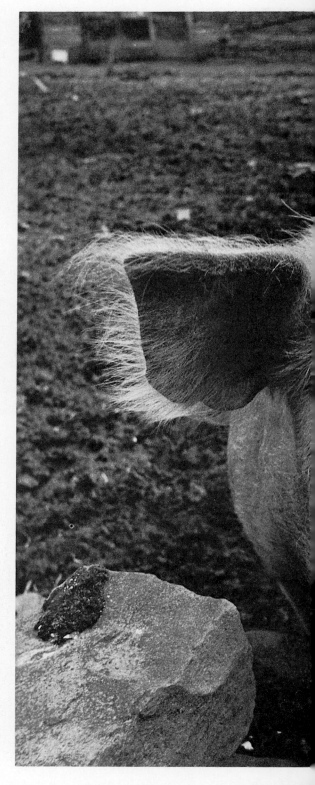

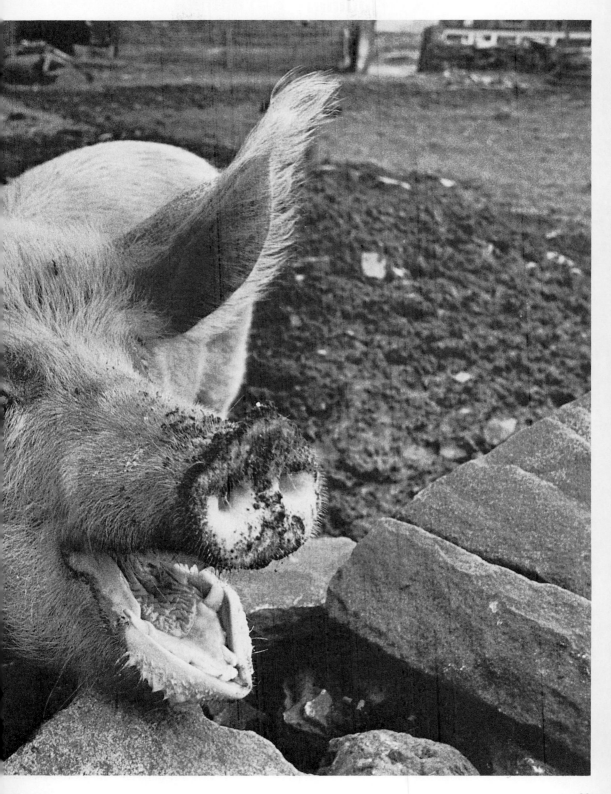

6.3 Two typical general-purpose developers. They are universal formulae suitable for either film or paper.

	Ilford PQU	FX-12
Sodium sulphite (anhydrous)	50g	60g
Sodium carbonate (anhydrous)	60g	60g
Hydroquinone	12g	10g
Chlorquinol	–	6g
Phenidone	0.5g	0.5g
Potassium bromide	2g	1.5g
Benzotriazole (1% solution)	20ml	35ml
Water to	1 litre	1 litre
Dilution for film*	1 + 19	1 + 7
Dilution for enlarging paper*	1 + 9	1 + 3

*Dilutions are as recommended by the manufacturer.
1 + 19, for example, means one volume of the stock solution made up to 20 volumes by dilution with 19 volumes of water.

Always critically assess the prints made from your negatives. Examine them carefully and decide whether the contrast of the print is satisfactory and the tone reproduction is good. If the print appears too high, or lacking in contrast, you should try printing the negative again on a suitable grade of paper to optimise the tone reproduction, giving a full range of tones from white to black and with detail throughout the tonal range. Then, look at the recording of fine detail and, lastly, at the graininess of the print. Since the last two both depend on the tone reproduction it is important to get that right first. If you have no sense of the image being inadequate all is well. If you have doubts you may need to try a slower film that will be more likely to give you high definition and fine grain. A change of film may solve that problem for you but may raise others if you are short of light!

If the change of film is not a success then you should look first for a general-purpose developer described as being a fine grain type but causing no loss in effective film speed. The quality obtainable with these developers is very good and should meet your needs. A typical result of the careful use of general-purpose development is shown in fig 6.4. If you wish to experiment you can try diluting such a developer to the extent suggested by the manufacturer, typically with up to three parts of water to one of developer. This can increase the image definition. If you cannot see any improvement after diluting the developer it is probably not worth doing. It does, in any case, mean that you have to discard it after use in most cases.

Only when you have tried approaches such as those discussed above and you have found them to be inadequate is it worth your while to use the special-purpose developers and procedures illustrated in the later chapters of this book. On the other hand, you can challenge yourself with the pursuit of quality so that you can make large, striking black-and-white prints from small negatives and still be satisfied with the sharpness and graininess as well as the total quality.

You should note that developing the negative and the print forms only two links in a chain which also includes yourself, the camera, the film and the printing paper. A deficiency of any link in this chain can spoil the quality. You should try to maintain the quality of the chain as a whole and not misapply your efforts by undue concentration on the developer alone. Camera shake due to the selection of too long an exposure, for example, cannot be remedied by any refinement of development technique!

6.4 The use of a general-purpose film-and-developer combination can give very good quality. This example is a print made from a negative shot on Ilford FP4 film developed in Kodak D-76.

21 A weakness of technique at any stage in taking, developing or printing makes it very difficult for you to make the best of an opportunity such as this. Technical and aesthetic ability have combined to produce this engaging portrait of fashion photographer Norman Parkinson.

7 POSITIVE RESULTS

It is probably true that the bulk of your photographs are taken with a view to making a positive image. These may be paper prints or positive transparencies, sometimes called diapositives. You can get either or both results from the use of conventional black-and-white negative film. This chapter is concerned with the processing of paper prints and film diapositives.

Developing prints

The development of printing paper has already been introduced in Chapter 4. In this section you will find more details of the developer and especially the other necessary processing solutions.

A typical print developer is shown in fig 4.1. A further, more modern formulation, is shown in fig 7.1. You will see that high contrast is ensured by a high proportion of hydroquinone relative to the second developing agent in each case, together with the incorporation of the carbonate accelerator giving a fairly high alkalinity (in chemical terms a high pH, where pH is defined by $pH = -\log_{10}$ (concentration of H^+)). Phenidone is a particularly useful developing agent for prints because it is non-staining, is unlikely to cause dermatitis (unlike metol), and, being relatively insensitive to the restraining effect of soluble bromide, enables you to make use of a developer of constant activity up to a high print throughout.

You may notice that active developers such as D-19 (fig 3.11) are also designed to give high contrast and a large working capacity. More common negative developers are less robust in design. Prints developed in several developers are shown in fig 7.2 which compares a print developer with an active negative developer and one designed to give negatives of high acutance.

You can expect the image to begin to appear after about 30 sec in each of the developers described (figs 4.1 and 7.1). A further $1\frac{1}{2} - 2$ min is then required for optimum development. Modern proprietary print developers, especially those designed for resin-coated papers, produce the first visible signs of an image after only about 10 sec and you can remove the completely developed print from the developer after one minute. After about 75 per cent of the recommended development time you will see no noticeable change in contrast but some change in print density may be apparent. If you prolong print

7.1 A modern print developer. Ilford ID-62.

Sodium sulphite (anhydrous)	50g
Hydroquinone	12g
Sodium carbonate (anhydrous)	60g
Phenidone	0.5g
Potassium bromide	2g
Benzotriazole (1% solution)	20ml
Water to	1 litre

The developer is diluted with three times the volume of water for use with typical bromide papers.

development you increase the effective speed of the printing paper but not its contrast. An example of such behaviour is shown in fig 7.3. Very prolonged development will lead to fog, the development of unexposed areas of the paper, especially if you have nearby safelights. 'Safe', in this context, is a relative term!

After developing the print you should immediately stop development and then fix the print. The stop bath can be a proprietary type or something cheap and simple like 2 per cent acetic acid. The fixer may be a traditional hardening type or a modern rapid hardening and fixing solution. Hardening is useful because of the high drying temperature that is commonly used with prints. Typical useful fixers are shown in fig 7.4. You should use rapid fixer of the type shown in fig 7.4C with some care owing to the risk of image-bleaching on prolonged immersion, especially at elevated temperatures.

The all-important wash then follows. Traditionally, some 30 min of washing in running water is required for print stability, but, as noted previously, with modern resin-coated papers a mere 2 min is considered adequate. Even with traditional fibre-based papers the washing can be speeded up. Wash the prints for some 5 min after fixing and then immerse them in a hypo eliminator (fig 7.5), or other washing aid, for the time recommended by the manufacturer – typically 5 min. After the washing aid treatment you simply wash the prints again for another 5 min and then dry them by your usual method.

Black-and-white reversal processing

It is quite possible for you to develop a conventional black-and-white negative film to give positive transparencies suitable for projection. What you have to do is to bleach away into solution the

7.2 Prints developed using,
A standard print developer,
2 min at 20°C, **B** active
negative developer, 2 min
at 20°C, **C** developer
designed to give negatives
of high acutance, 4 min at
20°C (no image was visible
after 2 min).

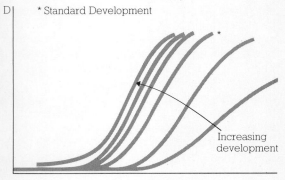

7.3 Development-time
series for a typical printing
paper.

7.4 Fixers for printing papers.

A Acid fixer – Ilford IF-2.

Sodium thiosulphate (hypo)	200g
Potassium metabisulphite	12.5g
Water to	1 litre

For use with printing papers dilute with an equal volume of water.

B Acid hardener fixer – Agfa 302.

Sodium thiosulphate (hypo)	200g
Potassium metabisulphite	20g
Potassium alum	15g
Sodium sulphite (anhydrous)	7.5g
Acetic acid (glacial)	12ml
Water to	1 litre

C Rapid hardening fixer – Kodak F-7.

Sodium thiosulphate (hypo)	360g
Ammonium chloride	50g
Sodium sulphite (anhydrous)	15g
Acetic acid (glacial)	14ml
Boric acid	7.5g
Potassium alum	15g
Water to	1 litre

7.5 A hypo eliminator for paper prints.

Hydrogen peroxide (10 volume)	125ml
Ammonia (3% solution)	100ml
Water to	1 litre

The reversal process

Subject

Exposure

Invisible latent image

Development

Developed image + unchanged silver salts

Bleach

Unchanged silver salts

Exposure & development

Developed image only – a positive

Wash & dry

7.6 Outline of a black-and-white reversal process to give a positive transparency suitable for projection.

developed negative image, without any prior fixation, and then develop the residual undeveloped silver salts. The process is illustrated in fig 7.6.

The first solution is an active black-and-white developer which also contains a silver halide solvent. A high-contrast negative image is formed in the first developer and, after washing the film, you then bleach it to form soluble silver salts. These dissolve away completely leaving a residue of reduced bleach salts which you remove using a clearing bath. You then wash the film once more and expose the remaining unaffected silver salts to a photographic flood lamp. Complete development of the totally fogged remaining silver salts yields the positive image that you want. Follow a quick rinse with a final acid-hardening-fixer and a lengthy last wash.

The effect of the silver halide solvent on the final result is shown in fig 7.7. In practice, the maximum density developable in most black-and-white negative and reversal films is higher than you need. If you include a fixing agent (a silver halide solvent) at low concentration in the first developer then the silver salts present in the undeveloped emulsion are partly dissolved away during that development stage. This reduces the final maximum density but also lightens the image at any exposure level. This, in effect, corresponds to

7.7 The effect of silver halide solvent concentration in the first developer of a black-and-white reversal process. An increase in the solvent concentration reduces the minimum density to a constant low level while all other densities continue to be further reduced by increases in the solvent concentration.

Similar results are obtained if the solvent concentration is kept constant and the first development time is increased. In each case the effective speed of the film is increased, ie, less exposure is required to obtain a particular developed density.

an increase in emulsion speed and can cause a useful increase with many negative films.

The solvent developers and the nature of the bleach baths used in such processes can cause problems with some films. It is best to use a process approved by the film manufacturer or sold specifically for the film in question. The solutions used in two reversal processes are shown in figs 7.8 to 7.11. Two processing sequences are shown in fig 7.12 using the solutions illustrated in figs 7.8 to 7.11.

While these sequences and solutions have been recommended by the two manufacturers, in at least one particular, they differ from current practice which involves a proprietary developer for which no formula is published. You should, however, be able to use these solutions as a basis for experiment if you wish to formulate your own.

7.8 First developers used in black-and-white reversal processes recommended by Kodak and Ilford.

	Kodak D-168	Ilford ID-36 + hypo
Metol	2g	3g
Sodium sulphite (anhydrous)	90g	50g
Hydroquinone	8g	12g
Sodium carbonate (anhydrous)	44.5g	60g
Potassium bromide	–	4g
Potassium thiocyanate	2g	–
Sodium thiosulphate	–	10g*
Water to	1 litre	1 litre

*Approximate figure; experiment is required to establish the optimum for any particular film application.

In each case the developer should be diluted for use with an equal quantity of water.

22 Great care has been taken with suitable development to ensure clean whites and detail throughout the tone scale in this difficult against-the-light situation. Unsuitable development can make the whites grey and lose highlight and shadow detail.

23 Pictures containing extremes of contrast and little mid tone give the impression of greater resolution, especially with linear subject matter.

24 A high-contrast subject gains little in a paper print. The greater contrast of a projected transparency can make the brilliance of highlights and the adjacent rich black shadows seem more dramatic. This print has been made on grade 5 paper to achieve a degree of abstraction and to stress the design elements.

7.9 Bleach baths for reversal black-and-white processes.

	Kodak R-21A	Ilford
Potassium permanganate	–	4g
Potassium dichromate	50g	–
Water to	1 litre	1 litre
Sulphuric acid (concentrated)	50ml	20ml
Dilution for use	1 + 9	–

DANGER Concentrated sulphuric acid should be added very slowly, with constant stirring, to a cooled dichromate or permanganate solution, *never* the reverse.

7.10 Clearing baths for black-and-white reversal processes.

	Kodak R-21B	Ilford
Sodium or potassium metabisulphite	–	25g
Sodium sulphite (anhydrous)	50g	–
Sodium hydroxide	1g	–
Water to	1 litre	1 litre

7.11 Second developers for black-and-white reversal processes.

	Kodak D-158	Ilford ID-36 + hypo as above
Metol	3.2g	
Sodium sulphite (anhydrous)	50g	
Hydroquinone	13.3g	
Sodium carbonate (anhydrous)	69g	
Potassium bromide	0.9g	
Water to	1 litre	

Dilute D-158 with an equal volume of water for use.

7.12 Black-and-white reversal processing sequences.

	Kodak D-168	Ilford ID-36 + hypo
First developer	5-10 min, 20°C, stock or diluted 1 + 1	12 min, 20°C, diluted 1 + 1
Wash	5 min	3 min
Bleach	R-21A 3-5 min	Permanganate bleach 3-5 min
Wash	–	2-5 min
Clear	R-21B 2 min	Metabisulphite clear 2 min
Wash	½ min	2 min
Re-expose	2½ min	1-2 min
Second developer	D-158 2-5 min, 20°C, diluted 1 + 1	As first developer
Wash	Rinse	Rinse
Fix	Acid hardening fix 5 min	Acid hardening fix 5 min
Wash	15-30 min	30 min

Agfa market a special, rather slow ISO 32/16° (ASA 32/16 DIN) black-and-white reversal film called Dia Direct, which you expose and then return to the manufacturer for processing. This is very convenient but the film speed is rather low for some purposes and it is perfectly possible to use moderate-speed negative film rated at ISO 200/24° (ASA 200/24 DIN) when reversal processed.

Negative-positive transparencies

An alternative way to make black-and-white slides is to print your negatives on a suitable black-and-white print film. Such print films include the 35mm fine-grain release positive films designed for making motion-picture prints for projection. You can also use high contrast sheet films.

In most cases, a conventional monochrome print developer is suitable for developing black-and-white transparencies prepared by printing conventional negatives. What you need is high contrast with low fog – exactly the qualities required of a paper print.

You can even use lith films (of very high contrast, designed for graphic arts use, see Chapter 14) with print developers, to give a suitable contrast for producing projection transparencies, although some dilution of the developer may be required, depending on the emulsion and the developer. You can try your normal print developer with a lith print or two by inspection – you can stop development when there seems to be a strong enough image. Bear in mind that the unfixed image seen under a safelight may well look darker than the fixed image viewed in room lighting. Establish a satisfactory development time for your system and use it as a standard for all such prints.

25 Abstraction obtained by high contrast treatment can be particularly effective in a projected transparency, especially with black-and-white.

8 TOWARDS ULTIMATE SPEED

The photographic films you buy are all given an ISO/ASA speed rating by the manufacturer. This corresponds to what can be regarded as normal development in a general-purpose developer. Developers described as giving higher or lower film speed simply relate to the standard speed rating. If the minimum useful exposure is reduced by a development procedure, the film speed is said to have been increased.

Extended development

To some extent you will find that simply increasing development time with a conventional developer can increase the effective film speed. Typical development time behaviour for a fast negative film is shown in fig 8.1 – the exposure required to obtain an image density of 0.1 above the minimum decreases with an increase in the development time. The contrast also increases with development time and may well produce negatives that are very difficult to print if the subject is of high contrast. If you want reasonably good quality in your photographs it is unwise to prolong development unduly. Graininess in the print increases quite rapidly with negative development and, as already observed, the contrast may become unmanageable for anything other than underexposed negatives.

The effects of extended development of a negative film are shown for enlarged prints in fig 8.2. At the minimum development time of 4 min the film, at its rated ISO 400/27° gives satisfactory results when printed on a soft grade of paper. At the same development time the film, rated at ISO 400/39° can give comparable tone reproduction for the model's face when printed on a very hard grade of paper. It is not possible to achieve a satisfactory reproduction of both face and the extreme highlights of the model's dress, and the shadow areas are devoid of detail. Extended development to 8 min has enabled a recognisable rendering of the model's face to be obtained with the film rated at ISO 25600/45°, again using very hard paper. Extending development to 16 min has given a marked increase in graininess with no gain in overall detail (made worse by movement of the sun during the series of exposures so that the model's face became shadowed in this particular frame). The conclusion from this set of exposures and processing variations seems to be

26 Conditions of lighting and the shutter speed needed to stop motion can make it necessary for you to up-rate the negative film by modifying the development. Here a fast negative film has been moderately up-rated to give this arresting photograph.

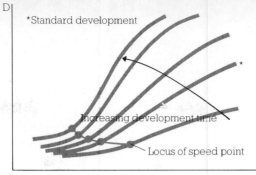

8.1 Development-time series for a typical negative film in a general-purpose developer. The speed is assessed at a density of 0.1 above the minimum for each development condition.

A

B

8.2 Extended development of a fast negative film in an active developer. Prints are shown from the following negatives: **A** 4 min development, film rated at ISO 400/27° (standard speed for the film), **B** 4 min development, film rated at ISO 6400/39°, **C** 8 min development, film rated at ISO 25600/45°, **D** 16 min development, film rated at ISO 25600/45°. The film used was Ilford HP5 developed in Kodak D-19; similar results would be expected with other fast films developed in such an active developer. Prints are 5 x enlargements.

27 A compensating developer giving enhanced speed with good definition and minimal increase in visible grain has been used to give good highlight and shadow detail in this photograph of an exceptionally high contrast subject in poor light.

that beyond some limit, which has to be determined for each film and developer, there is no useful speed increase to be gained by extending the development. Indeed, some properties of the image can be expected to get worse, notably the graininess of the print which is shown to be worsened by increased development.

Special developers

A number of proprietary developer solutions are specially formulated to give high emulsion speed. Their major feature, especially with fast emulsion, is that you can achieve considerable speed increases, typically up to three stops, without undue increase in contrast. Developers of this type have a compensating action, density increases with development time at low density levels while a less-than-proportional increase in density takes place at higher density levels. So effective speed is in-

creased while contrast stays controlled. This control of contrast makes the use of such a compensating developer advisable when the subject is of high contrast, otherwise it may be very difficult to print the negatives produced (fig 8.2.)

Formulae of some developers designed to give

8.3 Developers for increased film speed.

	Ilford ID-68	FX-11
Sodium sulphite (anhydrous)	85g	125g
Hydroquinone	5g	5g
Phenidone	0.13g	0.25g
Glycin	–	1.5g
Borax	7g	2.5g
Boric acid	2g	–
Potassium bromide	1g	0.5g
Water to	1 litre	1 litre

28 You can use compensating developers not only to cope with underexposure, but also to produce printable negatives from high contrast subjects. Here you will notice the high definition of the image and the presence of detail in the shadow areas.

79

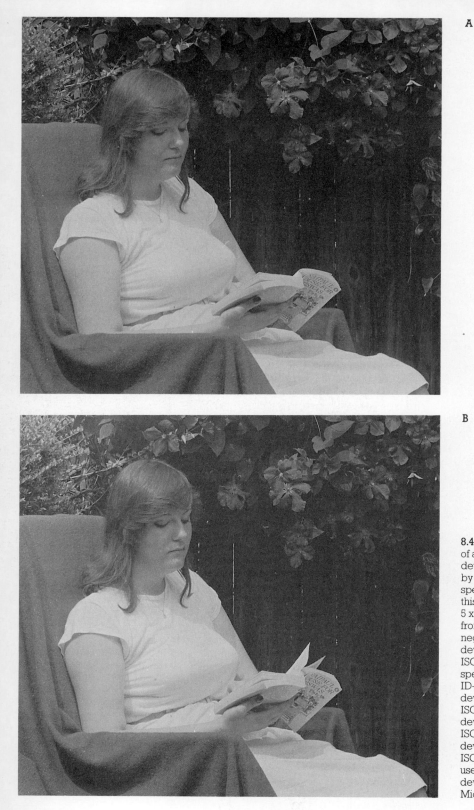

A

B

8.4 Extended development of a fast negative film in a developer recommended by the manufacturer for speed-enhancement by this method. Prints made at 5 x magnification are shown from the following negatives: **A** 5 min development, film rated at ISO 400/27° (standard speed for the film in, say, ID-11), **B** 5 min development, film rated at ISO 800/30°, **C** 9 min development, film rated at ISO 6400/39°, **D** 18½ min development, film rated at ISO 12800/42°. The film used was Ilford HP5 developed in Ilford Microphen.

C

D

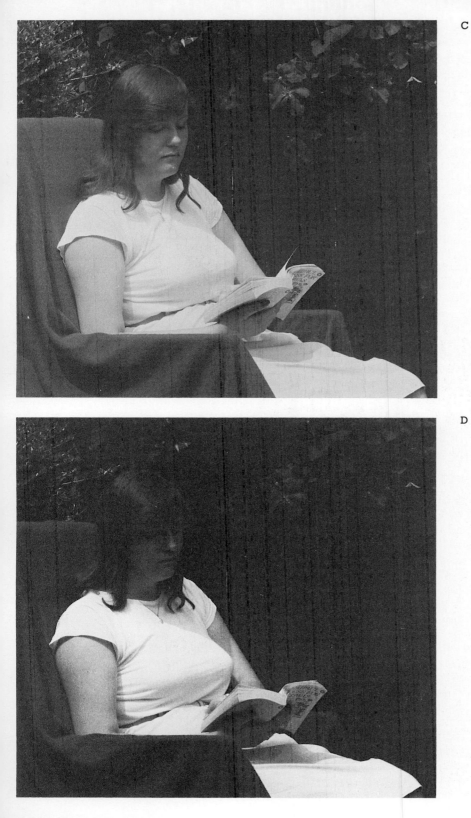

a high speed with normal contrast and minimum increase in granularity are shown in fig 8.3 from which you will see that the proportions of hydroquinone and of the other developing agents are kept low. This encourages local exhaustion in regions of high developed-density so that the contrast remains within bounds even during quite prolonged development.

Extreme underexposure

If you have to drastically underexpose even a high-speed film owing to low light levels very special treatments are called for. Considerations of quality become secondary to simply getting an image. In practice, some five or six stops of underexposure can still yield a recognisable image. Whether that is sufficiently good for your purposes is another matter. It is quite certain that a drastically underexposed picture of the first man to set foot on Mars is unlikely to be thrown away on the grounds of poor photographic quality if no other record exists. So you should not despair if you make an underexposure error. Simply try to rescue the film by one of the methods suggested.

Two simple approaches exist. The first, and simplest, is for you to use a highly energetic developer and to prolong development. A typical fast negative film normally rated at ISO 40027° can give, as we have seen, a usable negative rated at ISO 12500/42° – 25000/45° when developed for, say, 10 min in an active high contrast developer such as Kodak D-19. The formula for this developer is given in fig 3.11.

Similar results may be obtained by using one of the proprietary developers designed for high emulsion speed, Ilford Microphen for example, results from which are shown in fig 8.4. The prints obtained can be rather grainy and shadow detail will be lacking. Whether that makes the image useless depends on the photographer's needs. For photography at low light levels, including surveillance work, recognition of a face may be all that you require. In those circumstances you may not mind the lack of shadow detail.

Some developers have been devised especially for very underexposed negatives. One of these is shown in fig 8.5. You will notice the very high metol content associated with high emulsion speed, highly alkaline conditions for activity and a consequent need for a high level of restraint, provided by the potassium bromide content.

8.5 A developer for extremely underexposed films. Kodak D-82.

Methyl alcohol	48ml
Metol	14g
Sodium sulphite (anhydrous)	52.5g
Hydroquinone	14g
Sodium hydroxide	8.8g
Potassium bromide	8.8g
Water to	1 litre

This developer has a short shelf life after formulation.

High speed films

The approaches to very high speed described so far have involved normal high speed film and rather special development. These conditions apply if you get caught out by lighting conditions. You can, however, be prepared by equipping yourself with a suitable high speed recording film.

Such films are obtainable with a speed rating of up to ISO 4000/37° when you process them in a stipulated developer. With these special products it can be quite important to use the recommended processing if optimum quality is to be achieved. Results are shown for such a combination of recording film and the stipulated developer in fig 8.6. You will see that this very high speed film is able to record usefully even the shadowed face of the subject when rated at ISO 25600/45° and developed for 9 min in Kodak DK-50. This is evidently a marked advance on the performance of more general-purpose fast negative films.

Practical points

As in all departures from the norm, you should ideally experiment with treatments and materials for the highest emulsion speeds before you need to use them. You can then optimise procedures to suit your own needs.

If you are forced by circumstances to underexpose a film without previous experience of the necessary rescue procedures it is worth considering doing a quick test on another film of the same type before trying special development techniques on the film that really matters.

Colour films

The extended development of colour negative film is not generally recommended by manufacturers because the colour balance of the film tends to be changed in an awkward way. While in colour printing you can correct for an overall colour cast you cannot correct a change in colour balance that varies with the density level. This

does tend to happen on extending the development of colour negative film. Processing laboratories do sometimes, however, effectively increase the speed of colour negative films if requested. In this case, the development time is increased and some penalty is paid in terms of graininess and the colour quality of the prints.

On the other hand you can often successfully follow manufacturers' instructions for the uprating of colour reversal film. The first, black-and-white, development of such films has much the same effect as with black-and-white films. Increased first development reduces the image density development in the second (colour) developer and an apparent speed increase results. In most cases the recommendations extend only to an increase in film speed of two stops because there is an inevitable loss of quality. The density range of such 'push-processed' transparencies is reduced, as compared with that of the standard result. The slope of the characteristic curve is increased indi-

cating harsher tone reproduction, the colour balance changes and graininess increases. All these trends become worse as you increase first development. So, limit to the degree of forced development is set by the acceptability of the image quality. An example at, or near, the limit is shown in fig 8.7. Recent results obtained for a family of reversal films are summarised in fig 8.8 where the criterion was acceptability rather than high image quality.

If you need only to be able to recognise the subject then a further increase in first development is possible. There is, however, a (high) limit to the achievable speed rating and you have to determine this limit for yourself, and even for the batch of film used. Results from very non-standard processing may not transfer well from one of film to another. So a change of batch requires experimental work to re-establish conditions for coping with various degrees of underexposure.

Chromogenic development and forced processing

The chemistry of colour development, described in Chapters 12 and 13, yields a silver image

29 This photograph used an uprated high speed film. A high contrast image has been produced and, in the original, the mid-tones reveal considerable grain.

8.6 The use of a high speed recording film and increased development to enhance the already high emulsion speed. Prints made at 5 x magnification are shown for the following negatives: **A** 6 min development, film rated at ISO 800/30° (slightly lower than the recommended ISO 1000/31°), **B** 6 min development, film rated at ISO 3200/36°, **C** 9 min development, film rated at ISO 3200/36°, **D** 9 min development, film rated at ISO 25600/45°. The film used was Kodak Recording Film 2475 developed in Kodak DK-50.

8.8 The effective speeds obtained using a family of colour reversal films and a range of first development times. Six minutes is the standard development time for the entire family.

Rated ISO speed	First development time (minutes)						
	3	4	6	8	11½	17	26
64/19°	10	32	64	80	128	512	800
200/24°	100	120	200	320	400	3200	12800
400/27°	100	150	640	800	2000	6400	8000

Note: This study revealed that the increase of first development time from 6 to 8 min gave harsher results that suited some brightly coloured subjects in particular. In certain cases therefore, this study confirmed the folklore that you can do better by uprating a slower reversal film than by using the most obviously suitable film. It should be emphasised, however, that this did not hold true where any subtlety of colour rendering was required, in recording pastel colours for example.

alongside the dyes formed. In the quest for ultimate speed you can use some extra chemistry to increase the amount of image formed.

Chromogenic development, in this context, is most easily carried out with films designed for the purpose, namely colour or monochrome chromogenic films which contain colour-forming chemicals. You could, however, also use similar chemistry with chromogenic developers containing colour couplers (Chapter 13) and conventional black-and-white emulsions.

The trick is to generate a negative image by extending the conventional development of the material to the maximum speed (by using a very active black-and-white developer) and to fix the emulsion thoroughly. You next wash the film and then bleach the silver image back to silver salts using a suitable rehalogenising bleach (see Chapter 13). The silver salts corresponding to the developed image are the only ones present at this stage so you can fog them totally with light and then chromogenically develop them to add to the originally developed dye image. In theory, you can repeat the bleach and development cycle more or less indefinitely as long as you have an adequate supply of couplers present to go on forming the image dyes. In practice, the graininess of the images obtained becomes very noticeable and is one aspect of a rapid loss of image quality as the cycle is repeated. It is usual to stop the repetition with developed silver present in the emulsion to reinforce the dye image. Experiment will tell you how far you can go and still get a useful print from such a push-processed negative. Generally, it is much better to avoid using colour negative film for such treatment because the film tends to be too highly coloured without any development having taken place. Much of the unwanted coloration is likely to remain after the process and will make the negatives difficult to print in black and white.

A practical point is that if you formulate a colour-forming developer incorporating a coupler, the image is most effective for printing purposes if the dye formed is yellow.

30 You may need to resort to low contrast development to retain detail in the highlights and shadows of a subject with such a wide contrast range. The negative may then print successfully on a normal grade of printing paper.

9 CONTROLLING CONTRAST

Printing paper is manufactured in a range of grades designed to cater for negatives of different density ranges. If the subject luminance (brightness) range is such that a normally exposed and developed negative has a density range greater than can be accepted by the paper grades, you are in trouble. Printing becomes very difficult unless you can change the development conditions to control the range of negative density.

Low contrast development

To reproduce in the print all the subject tones without loss of information, subjects with a very high luminance range demand low contrast development of the negative film. A similar problem arises if you use a high contrast, high definition film for pictorial purposes. High contrast is not confined to scenes which contain naked flames or other light sources. Such architectural interiors as mainline railway termini or cathedrals may have shafts of sunlight brightly illuminating the highlight areas while other important details are in deep shadow. An example of a high contrast subject is shown in fig 9.1; care was necessary to control the negative density range and to keep it within printable limits.

The simplest way to reduce the negative density range is to develop your film for a shorter time. Unfortunately, if you do this you also reduce the effective film speed. Through experience you may establish a rule of thumb for one particular film and developer combination, relating effective speed to the degree of development reduction. The underdevelopment of modern negative materials may, in fact, give you a useful bonus with tone reproduction. In many cases the characteristic curve of the film is closer to a straight line when underdeveloped and this may help tone rendering, particularly in highlight areas.

An alternative to reducing development time is to dilute a general-purpose developer. The dilution may have to be as much as 1 + 5 or even greater. The characteristics of the developer are likely to be changed considerably by a significant degree of dilution. Development of high densities is more restricted than that of low densities – the developer assumes a compensating character and you can often increase development time to achieve near-normal emulsion speed while the contrast remains low. Such conditions are also conducive to improved definition, as described in the next chapter. Dilute developers generally do not keep well and should be discarded after use.

9.1 A high contrast subject demanding control of the negative density range.

In extreme cases, and with high contrast films of high definition, you will find it more satisfactory to use a developer specially formulated for the purpose than to struggle with a diluted general-purpose type. Special low contrast developers usually contain only low concentrations of developing agent, together with moderate concentrations of sodium or potassium sulphite and very little else. No restrainer is used, nor is it desirable since bromide, for example, tends to hold back emulsion speed and to increase contrast. The formulae of two low contrast developers are shown in fig 9.2. The developer POTA was used to control the contrast of the film on which fig 9.3 was shot.

9.2 Special low contrast developers.

	POTA	XDR-4
Potassium sulphite (anhydrous)	–	25g
Sodium sulphite (anhydrous)	30g	–
Phenidone	1.5g	–
Metol	–	1g
Hydroquinone	–	1g
Potassium bicarbonate	–	10g
Water to	1 litre	1 litre

(Strictly, the term 'low contrast' is only applicable to the developed image and not to the developer or film used.)

High contrast development

You may sometimes need to develop film to a high contrast. Typical fields of application include the processing of medical X-ray films and aerial films, in which a full range of tones is required from rather a low contrast subject. A further application lies in graphic-arts processes in which the highest contrast is required with no rendering of intermediate tones (see Chapter 14.)

In the former case use is generally made of sodium carbonate as an accelerator with a relatively high concentration of hydroquinone together with metol or Phenidone and a high concentration of sodium sulphite. The formula of one such developer, Kodak D-19, is shown in fig 3.11 and a second in fig 9.4. These developers are very active, giving rapid and full development. The relatively high hydroquinone content and carbonate accelerator are primarily responsible for the high contrast achieved. You can use either developer to gain contrast while retaining a useful

31 Careful development is often required to get the most out of this type of subject. The subject is of quite high contrast yet in the print sky detail is needed to retain the mood of the original situation.

32 A very high contrast subject has been photographed, developed and printed to give a deep shadow, framing detailed mid-tones and clear highlights. These circumstances often call for special exposure and development of the negative.

91

9.3 A high contrast subject was photographed using a high-definition film, Kodak Technical Pan 2415, which requires the use of a low contrast developer under these circumstances if the image is to be printed without too much trouble. POTA was used to develop the film.

gradation giving a full range of tones. The solutions are stable, have a large working capacity and can be replenished to extend their useful life.

If you require much higher contrast you need caustic alkali accelerators with potassium metabisulphate to moderate the alkalinity and act as a preservative. Hydroquinone alone is used as the developing agent and a good deal of potassium bromide is present as restrainer to prevent undue fog formation and to hold back the development of those grains corresponding to the foot of the characteristic curve and hence to enhance the contrast. Such developers are illustrated in fig 9.5.

These developers are quite unstable and should be made up and stored as two parts, mixed only when required and discarded immediately after use. Single solution caustic hydroquinone developers do exist but are, at least potentially, less easy to store successfully.

High and low contrast development of a medical X-ray film are illustrated in fig 9.6 which compares the characteristic curves found from D-19 and POTA development.

9.4 A high contrast developer. Ilford ID-72.

Sodium sulphite (anhydrous)	72g
Sodium carbonate (anhydrous)	48g
Hydroquinone	8.8g
Phenidone	0.22g
Potassium bromide	4g
Benzotriazole (1%)	10ml
Water to	1 litre

9.5 Caustic hydroquinone developers for very high contrast.

		Ilford ID-13	AG70a
Solution A	Hydroquinone	25g	10g
	Potassium metabisulphite	25g	10g
	Potassium bromide	25g	2g
	Water to	1 litre	1 litre
Solution B	Potassium hydroxide	50g	20g
	Water to	1 litre	1 litre

Mix equal volumes of A and B immediately before use.

33 High contrast scenes can be further enhanced for visual effect and a degree of abstraction if you use high contrast development. You can then print the negative on normal paper to produce a more dramatic result.

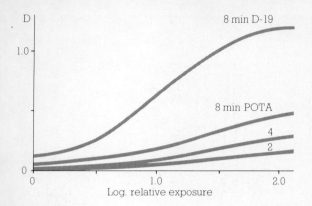

9.6 High and low contrast development of a fast medical X-ray emulsion.

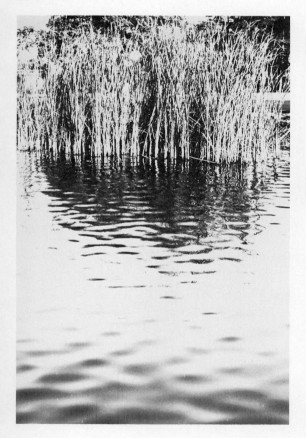

9.7 High contrast was achieved in this photograph of a low contrast subject by using extended development with a fine grain film. A roller-transport processing machine was used and you will observe a number of vertical lines on the print which represent scratches on the film caused, presumably, by dust particles either when the cassette was opened or at some later stage in the process.

Special developers for printing papers

When all printing paper grades from 0 to 5 are available there is little need for you to consider manipulating developer formulations with a view to controlling contrast. You would, indeed, risk undesirable changes in image tone – that is, the warm or cold appearance of the image. With some printing papers, however, the range of grades is restricted and grade spacings may be too widespread for some purposes. Consequently, you may need to consider controlling contrast by the developer formulation. An ingenious two-part developer system formulated by Dr Beer has been recommended in such cases. Formulae and proportions in use are shown in figs 9.8 and 9.9.

9.8 A two-part print developer (Dr Beer).

Part A	Metol	8g
	Sodium sulphite (anhydrous)	23g
	Potassium carbonate (anhydrous)	20g
	Potassium bromide	1.1g
	Water to	1 litre
Part B	Hydroquinone	8g
	Sodium sulphite (anhydrous)	23g
	Potassium carbonate (anhydrous)	27g
	Potassium bromide	2.2g
	Water to	1 litre

For use, the two parts are mixed and diluted according to the scheme shown in fig 9.9.

9.9 Mixing proportions for Dr Beer's two-part print developer.

Contrast	low						high
Mixture Number	1	2	3	4	5	6	7
Parts of A	8	7	6	5	4	3	2
Parts of B	0	1	2	3	4	5	14
Parts of water	8	8	8	8	8	8	0
Total	16	16	16	16	16	16	16

You will see that Mixture 1, giving the lowest contrast, is a carbonate-activated metol-only formulation while Mixture 7 has a high proportion of hydroquinone with increased alkali and gives the highest contrast.

Before you use such a system in earnest you could usefully do some experiments to see how your printing paper and enlarger system respond to the various mixtures. Once the system behaviour is known, you can control contrast very finely by using such a developer.

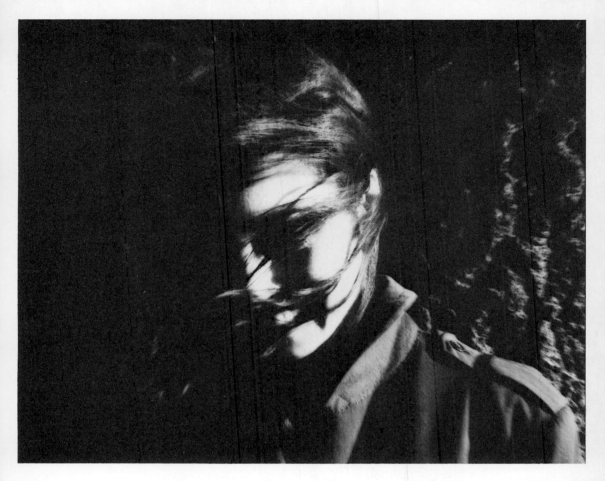

34 High contrast treatment has been used to accentuate that of the subject, to deliberately suppress shadow detail in the image and to suit the mood of the photograph – aptly titled 'Mystery Woman'.

10 THE PURSUIT OF QUALITY

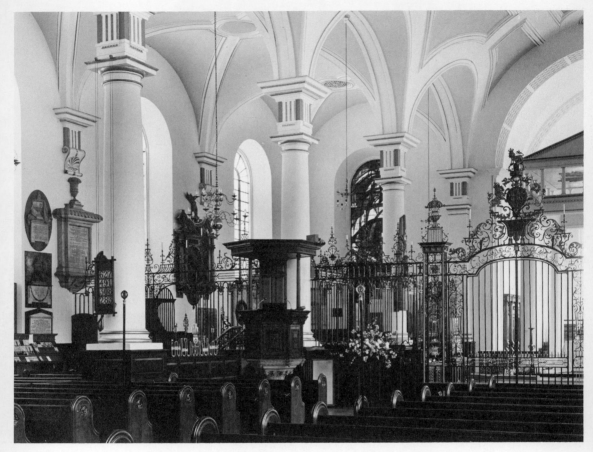

Most photographers seek to produce high quality results. Among the factors which combine to influence the quality are the sharpness and graininess of the print as well as the tone reproduction, which has already been discussed in Chapter 9.

Fine grain

It is generally true that slow films are less grainy than fast ones, so if you want to minimise graininess in your prints you can use slow, fine grain film. (The printing paper scarcely contributes to the graininess of the print because it is, in any case, a fine grain material and unlike the negative, is not enlarged during the production of the print.) There are, however, occasions when you may have to use a faster film. It then becomes particularly useful to be able to minimise the grain by choosing a fine grain developer.

Before considering the composition of such developers it is worth thinking about the form of the developed silver. If you use an active, high contrast, general-purpose developer, such as Kodak

35 In this photograph of a demanding subject you will see a full range of tones with detail in the highlight and shadow areas. The print is free from objectionable graininess and detail is well defined.

D-19, each grain is developed as a tangled mass of filamentary silver – rather like steel wool. On the other hand, a lower-activity developer, such as Ilford ID-11, gives you a smaller and more compact grain structure. The difference is due to the existence of two major mechanisms of development. The first, *chemical development*, involves direct reduction of the material of the grain and is typical of high-activity systems. The second, *physical development*, involves the reduction of silver salts in solution, usually at nuclei provided by developing latent-image centres. Low-activity systems allow more time for solvent effects to dissolve silver salts and hence tend to promote physical development and a partial grain reduction which, together, produce the much smaller

and more compact grain structure required.

So, to minimise grain you should use a developer solution with an ability to dissolve silver halide emulsion grains and with a low enough activity to allow the long development times which favour the physical development mechanism of grain reduction. A high-activity system tends to give too high a contrast and overall density if development is prolonged, and the grainy image has already formed before physical development is under way.

Developers formulated for this purpose generally contain a silver halide solvent to encourage physical development and a rather weak accelerator system such as sodium carbonate in very low concentration or, perhaps, borates. With very fine grain developers there is often up to one stop loss in effective film speed.

The features of fine grain development discussed in this section are broadly met by formulations such as Kodak D-76 or Ilford ID-11, shown in fig 10.1. This has become a standard fine grain developer, suitable for most films but not entailing any speed loss. One of the simplest of such fine grain formulae, Kodak D-23, is shown in fig 10.2 and comprises only sodium sulphite and metol dissolved in water. The high concentration of sodium sulphite provides the preservative, mildly alkaline accelerator and silver halide solvent, while metol serves as a developing agent and is

10.1 A fine grain developer which gives normal contrast and emulsion speed. Ilford ID-11, Kodak D-76.

Metol	2g
Sodium sulphite (anhydrous)	100g
Hydroquinone	5g
Borax	2g
Water to	1 litre

10.2 A fine grain developer giving low contrast with normal emulsion speed. Kodak D-23.

Metol	7.5g
Sodium sulphite (anhydrous)	100g
Water to	1 litre

active enough to give normal emulsion speed. If you need finer grain development than this, a significant speed loss is inevitable.

Ultra fine grain

Developers designed to give the finest grain possible usually display most of the features of the fine grain types already discussed. In addition, however, they often involve silver halide solvent properties of the developing agent itself. Thus the rather inactive compounds, paraphenylene diamine and its derivatives and analogues have found a use in these developers. Such compounds possess solvent properties for silver halides and form a very low-activity developing system when a very mild alkali accelerator is used. Many of

36 Many modern general-purpose developers, used with medium-speed film will give you fine grain results with excellent definition.

these developers do, in fact, rely on a high sulphite concentration alone to provide the alkali content. In others, borax or low concentrations of sodium carbonate can be used. Two such formulae are shown in fig 10.3. One looks reasonably conventional while the other uses a colour developing agent (although without the other chemicals required to form a colour image). The developing agent Kodak CD-3 is a substituted paraphenylene diamine commonly used as a colour developing agent. It gives a low development activity in the formula shown, with good solvent action giving a very fine grain structure.

10.3 Two ultra fine grain developers: **A** FX-5b, **B** Kodak (USPat 2193015).

A FX-5b

Metol	4.5g
Sodium sulphite (anhydrous)	125g
Borax	1.4g
Sodium hydroxide	0.3g
Sodium bisulphite	1.0g
Potassium bromide	0.5g
Water to	1 litre

B Kodak (USPat 2193015)

Kodak CD-3*	5g
Sodium sulphite (anhydrous)	30g
Sodium carbonate (anhydrous)	30g
Water to	1 litre

*Kodak CD-3 is 4-amino-3-methyl-N-ethyl-N-ß-methane-sulphonamido-ethyl-aniline sulphate.

Fig 10.4 compares results obtained from the development of films of medium and high speeds in a general-purpose fine grain developer which entails no speed loss and in a fine grain developer which roughly halves the effective film speed. All the prints were made on a normal grade of printing paper at 20 x enlargement. For each film the use of the special developer has given a less grainy print than the general-purpose developer. The less grainy prints are, however, also slightly less sharp in each case.

High definition

The recording of fine detail is, to a surprising extent, independent of the grainy appearance of a photograph. A grainy photograph may, indeed, have very good sharpness. It is sometimes argued that, with modern fine grain emulsions you really need the development conditions optimised for sharpness since the graininess will be very low in any case.

10.4 A comparison between prints made from negatives developed in a general-purpose fine grain developer and a very fine grain developer which halves film speed. The negatives were: **A** A medium speed film developed in the general-purpose developer, rated at ISO 125/22°, **B** The medium speed film developed in the special developer, rated at ISO 64/19°, **C** A fast film developed in the general-purpose developer, rated at ISO 400/27g, **D** The fast film developed in the special developer, rated at ISO 200/24°. Films: HP5, FP4. Developers: ID-11, Perceptol.

fresh developer at the high density side of the edge gives a higher density close to the boundary than elsewhere in the high density region. The arrival of bromide suppresses development of the low density region adjacent to the edge. The resulting effect is illustrated in fig 10.5 and shows an enhancement of the edge contrast which, at least partly, mitigates the inherent blurring of fine detail caused by optical effects in the camera and the emulsion. This explains the effect merely noted in Chapter 5.

When you use a high definition or high acutance developer you are setting out to encourage these edge effects. Such developers thus have certain features. It is important to use a developing agent which is strongly inhibited by development by-products and to ensure that conditions favour such 'poisoning' of the developer. Typically, metol is used at low concentrations so as to be quickly, and locally,

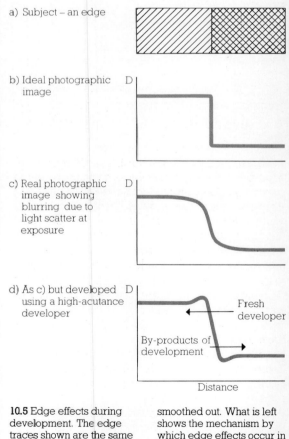

a) Subject – an edge

b) Ideal photographic image

c) Real photographic image showing blurring due to light scatter at exposure

d) As c) but developed using a high-acutance developer

Fresh developer

By-products of development

Distance

Sharpness in photographs has much to do with the recording of edge detail – what you might call the micro-contrast of the image. Indeed, measurements which agree with the visual impression of sharpness are made from images of edges (Chapter 5). During development, the edge between high and low density areas in a negative is a boundary between fairly exhausted and fairly fresh developer. At the boundary, sideways diffusion causes fresh developer to cross the edge into the high density region while by-products such as bromide cross the edge into the low-density region. In the right conditions, the availability of

10.5 Edge effects during development. The edge traces shown are the same as those in fig 5.6 but with the effects of granularity smoothed out. What is left shows the mechanism by which edge effects occur in high acutance developers, in D.

exhausted in high density areas. On the other hand it is useful to maintain emulsion speed as far as possible, so a high alkali content may be used to give good shadow detail.

One such solution, formulated by W. Beutler, is shown in fig 10.6. Other high-definition developers show a similarly low working concentration of developing agent, in the region of 0.5 g per litre, and a low concentration of a strong alkali. These conditions predispose the developer to local exhaustion but also give good emulsion speed. In some cases, pronounced gains in effective emulsion speed are achieved by extended development in such solutions because high contrast is achieved in regions of low exposure, and hence low developed density, while development at higher densities is restrained by exhaustion. This is the compensating action which you have already encountered in Chapter 9.

10.6 A high acutance developer (W Beutler).

Metol	5g
Sodium sulphite (anhydrous)	25g
Sodium carbonate (anhydrous)	25g
Water to	1 litre

For use, dilute one part of developer with ten parts of water.

37 You can stress the detail in subjects such as the glass houses in this photograph by the use of a high definition developer specially formulated to enhance edge effects in the negative without causing undue graininess in the print.

The susceptibility of such developers to bromide poisoning means that agitation is important if you are to avoid development streamers appearing on the negatives due to uneven bromide concentration during development. On the other hand, too much agitation will reduce the *adjacency*, or edge, effects which improve the image sharpness. In the absence of any other instructions you should agitate the developer every minute during development.

Special high-definition films

It is becoming increasingly common for special high-contrast, high-definition films, such as Kodak Technical Pan 2415, to find their way into general pictorial use. As the emulsions are generally quite slow and of high contrast, their use can cause problems. The inherent sharpness and granularity of the films is so good that the major criterion for development is usually the tone reproduction – there is simply no need for you to use special fine grain or high-definition developers.

In general use you need a low contrast developer for these films. Proprietary developers of this type, such as Kodak Technidol LC, are becoming available commercially, but formulations have been published for low contrast developers and two examples are shown in fig 9.2. Of these developers POTA is commonly recommended for use with high-definition films and you may notice that it is almost a Phenidone analogue of D-23 (fig 10.2) but much less concentrated. As a result it achieves a manageable negative density range, even with high contrast, high-definition films. You will probably need to experiment to determine suitable speed ratings and development times for such film/developer combinations under your conditions.

If you cannot make up special low contrast developers there is no reason why you should not experiment with considerable dilution of a suitable lowish-contrast (sometimes called soft-working) general-purpose developer such as D-76. The simplest procedure is, of course, to buy the manufacturer's recommended developer for the film being used.

You therefore have two possible approaches to getting high definition: firstly, the use of normal films with high-definition developers and, secondly, the use of special high-definition films. The two approaches are compared in fig 10.7. Prints are shown from a medium speed film

A

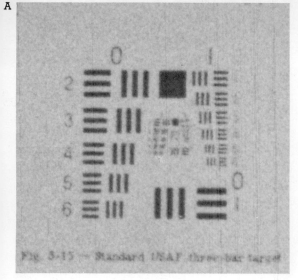

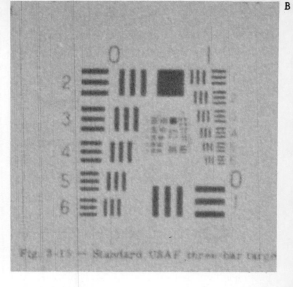

B

10.7 Approaches to high definition, three enlargements of: **A** medium speed negative developed in a general-purpose fine grain developer, **B** medium speed negative developed in a high acutance developer, **C** high-definition film developed in a low contrast developer.

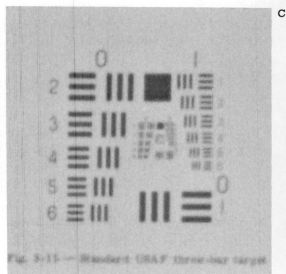

C

developed in a general-purpose developer and in a high acutance developer, and also from a high-definition film developed in POTA. For the medium speed film there seems little or nothing to gain from the use of the high acutance developer in preference to the general-purpose fine grain type. The slow high definition film reveals limited field depth at the taking stage but the spine of the book immediately beneath the resolving-power test chart shows a clarity not achieved in either of the other two prints, and the graininess is also much lower. Further prints from high-definition negatives are shown in fig 10.8.

A

B

10.8 The use of high-definition film. The following magnifications are represented in the original prints: **A**, 5x **B**, 10x. The film was Kodak Technical Pan 2415 developed in POTA.

38 If you use special high definition developers you may find that, with some films, the graininess of the final prints is increased. This is not always a drawback and may, indeed suit the subject.

11 QUICK RESULTS

Sometimes, the most important factor in processing is urgency. A number of techniques, and even whole processes, have been devised to give rapid access to the developed image. In some cases that is all that matters – questions of image stability are irrelevant.

Quick-finish developers

The rapid processing of conventional photographic films requires a developer of very high activity, typified by the caustic hydroquinone formula shown in fig 11.1. This developer contains a high concentration of hydroquinone as the sole developing agent, with caustic soda (sodium hydroxide) as the accelerator and a high bromide concentration to restrain the fog level. The developer is capable of giving very high contrast but you can keep this to tolerable limits by a short development time – around 2 min at 20°C (68°F).

11.1 A quick-finish developer. Kodak D-8.

Sodium sulphite (anhydrous)	90g
Hydroquinone	45g
Sodium hydroxide (caustic soda)	37.5g
Potassium bromide	30g
Water to	1 litre

Dilute two parts of the solution with one part of water for use.

Another method of rapid development, also at room temperature, requires rather unusual methods. The most rigorous of these involves highly alkaline solutions which would destroy the emulsion gelatin if immersion were for longer than a few seconds, and which would make a very unstable developer formulation. To avoid these problems you make up the developer as two separate baths. Constituents of suitable baths are given in fig 11.2.

11.2 An ultra-rapid two-bath developer.

Bath 1	Hydroquinone	50g
	Sodium sulphite (anhydrous)	25g
	Water to	1 litre
Bath 2	Potassium hydroxide	300g
	Potassium bromide	1g
	Safranine	0.2g
	Water to	1 litre

The first bath, in which you immerse the film for only 2 sec, contains a high concentration of hydroquinone with sodium sulphite and should be reasonably stable. The second, to which you then transfer the film, is an alkaline potassium hydroxide solution which gets development going very quickly. It contains potassium bromide as restrainer and a small quantity of safranine which prevents emulsion fogging due to atmospheric effects.

Development is continued for 2 sec in this second bath. You can then transfer the film to a stop bath and inspect the image. It is reported that, by using an alkaline hypo fixer, you can complete fixing in times as short as 5 sec if you transfer the film directly from the second developer bath to the fixer.

While the stopped or cleared image may be sufficiently useful, you may need a print from the negative as soon as possible. This can be done quickly if the wet, fixed, film is squeegeed between sheets of dry, clear film base. You can then print the sandwich without unduly contaminating the enlarger, the printing paper or yourself.

Stabilisation processes

A rapid-access process, particularly suitable for print materials, relies for development on the presence of a developing agent, typically hydroquinone, in the emulsion itself. The developing agent is not photographically active in the slightly acid or neutral conditions of the coated emulsion but can be activated by alkali. After exposure, you activate the developing agent by immersing the print in an alkaline activator solution – usually in a simple processing machine such as that seen in fig 11.3. Development takes place in seconds and is immediately followed by a stabilisation stage. The undeveloped silver salts are converted into a more stable complex salt which need not be washed out of the emulsion. The chemicals necessary to achieve this are supplied by the second processing solution, the stabiliser, present in the processing machine. Unless you are prepared to fix and wash the stabilised print like any conventional material the print should be left alone after emerging 'touch dry' from the processing machine. The total processing time is of the order of fifteen to twenty seconds.

39 Classically, quick results were required for photo-finish records and for press photographers eager to be first with the news. You have to take special care with very active developers to avoid too high a contrast.

image. Only a complete conventional fix and wash procedure is permissible for a stabilisation print, and this treatment will make the image as stable as one produced by conventional materials and processes. The stabilised (but unfixed and washed) image does not have good long term stability, so if lengthy storage is envisaged for the prints, fixing and washing are advisable.

The total time between starting ultra-rapid development of the negative and receiving a stabilised print can be as little as one or two minutes. A major time saver is, of course, the omission of the final washes. After viewing the print you can, if necessary, fix, wash and dry it like any other bromide print. It will, in fact, be practically indistinguishable from a fibre-based bromide paper print. Stabilisation printing papers are not resin-coated because excess chemicals

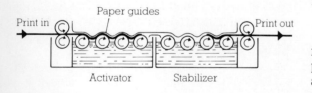

11.3 An activator/stabiliser processing machine for developer-incorporated photographic materials. The print is received 'touch dry' after about 20 sec.

The stabiliser solution can contain any of a wide range of suitable salts including ammonium thiocyanate in a partly alcoholic solution to ensure rapid drying. It is important not to remove any of the necessary excess of the stabiliser salt present in the processed emulsion. Any well-meant rinse of such a print will lead to gross instability of the

40 You can take advantage of quickly-processed negatives by making prints on stabilization papers. The results you obtain can be very good and virtually indistinguishable from conventional prints, although the stability of the image is less good.

have to be absorbed by the base. An impermeable base causes problems with surface crystallisation.

Monobaths

The idea of combining developer and fixer in one active solution, a monobath, is appealing to many photographers. In practice, you cannot simply mix your developer and fixer together and expect to get useful results. Instead, you have to buy or make up a specially formulated solution which will, however, do both the important tasks of developing and fixing your film in one processing bath.

Special formulation is necessary because you want development to be completed before the fixer can remove the silver salts you wish to develop. This race between chemical reactions is biased in favour of development by a number of factors built into the formula. A typical example is shown in fig 11.4. A strongly alkaline solution of hydroquinone and Phenidone does the developing (probably quite rapidly) and hypo is present at about half the usual concentration for fixing baths.

11.4 A monobath developer.

Sodium sulphite (anhydrous)	50g
Hydroquinone	12g
Phenidone	4g
Sodium thiosulphate (hypo)	110g
Sodium hydroxide	4g
Water to	1 litre

The control of monobath development is of interest. The contrast (gamma) achieved by a film developed in a monobath depends on the composition of the bath and the temperature at which it is used. Contrast is not affected by development time, only by the relative rates of the competing reactions of developing and fixing. To some extent you can control this

relationship by changing the temperature.

You may vary the composition of the solution provided that you can make it up yourself. Guidelines for experiments to get speed and contrast to a desired standard are fairly clear. If you want to increase speed and contrast you must also increase the relative rate of development by one or more of the following changes: make the bath more alkaline (raise the pH), increase the amount(s) of the developing agent(s), raise the temperature, and perhaps reduce the hypo concentration. If you vary the relative concentrations of the developing agents you can control the relationship between speed and contrast – a higher hydroquinone content increases contrast, while more Phenidone raises the speed. If you want to reduce speed and contrast, then make the bath less alkaline (lower the pH), lower the concentration of developing agents, lower the temperature or increase the hypo concentration.

A few very rapid monobath formulations have been published and in general they rely on a very high pH, achieved by using potassium (or sodium) hydroxide, high concentrations of developing agents and exotic sulphur-containing organic chemicals as fixing agents. Such monobaths achieve processing times of a few seconds at quite high temperatures, 45 – 50°C (113 – 122°F). A monobath formula is given in fig 11.5.

11.5 An ultra-rapid monobath developer.

Potassium sulphite	20g
Antimony potassium tartrate	40g
Phenidone	3g
Hydroquinone	60g
α – Thioglycerol	150ml
Water to	1 litre
Potassium hydroxide	to pH 12.65

The resources of a chemical laboratory are needed to make up this solution because an accurate determination of pH is required.

Diffusion transfer processes

In monobath processing the chemical environment is one in which silver salts are in solution together with alkali and developing agents. These are the conditions required for physical development – not of emulsion grains directly, but by the deposition of silver produced by reduction of silver salts in solution. This type of development takes place alongside conventional chemical development of the emulsion grains. It can also

occur at any nuclei such as latent-image centres suitable for the growth of a speck of physically developed silver. You may find that finger prints on films and a multitude of other items can similarly serve as development nuclei. The surfaces of your developing tanks and spirals may also become decorated with metallic silver when you use such processing solutions.

If you sandwich the developing film with its monobath developer against a film coated only with very tiny development nuclei dispersed in gelatin, you can see an interesting application of physical development. The quantity of silver salts dissolving in the monobath is greatest in areas of little development and least where a lot of image develops in the film. If physical development takes place at the nuclei in the sandwiched film then most will occur where the developed emulsion has received least exposure, and vice

11.6 Diffusion transfer, peel-apart process yielding a positive image. The two cross-section views show the stages of chemical development of the negative and the simultaneous diffusion of silver salts from the negative to the positive, also the final physical development of the positive image.

versa. The process is shown in fig 11.6. Note that a positive reproduction is obtained on the sandwiched film.

In practice, such processes are used for films of sufficient speed for camera use, typified by the Polaroid system, and have also been used for document copying systems made by both Agfa and Kodak using paper negative materials. Edge effects may be quite pronounced with such processes and therefore give very good rendering of fine detail. If you make large transparencies for visual aids or other purposes, you can see directly the sequence of events shown in fig 11.6. Active chemical development of the negative image is followed by slower physical development of the transferred image. A point to note is that the physically developed image, being formed of very small particles, uses the silver more efficiently than the chemically developed image. The transferred image can therefore achieve a much higher density than the residual negative.

It is usual to discard the negative in such processes, but in a few cases you can stabilise the residual negative by immersion in a bath sold for the purpose. This can be particularly useful if multiple positives are required. Only one camera exposure is necessary, with almost instant access to the corresponding positive so that you can check lighting, composition and exposure level.

You can then make the multiple prints at leisure by conventional printing methods.

In most camera systems the only intervention you can make in development is to peel the two materials apart earlier or later than the ten seconds or so normally recommended after the sandwich emerges from the camera. Markedly shortened development time could be expected to give you a lighter positive but prolonged development may not make the positive very much darker than usual.

Document-copying and litho plate preparation processes usually require you to feed the exposed full-sized paper negative material into a processing machine while facing, but not quite in contact with, the image-receiving material. The activator solution floods the surfaces of the materials which are then squeegeed together and expelled from the machine. After about 60 sec you peel apart the materials and you can, to some extent, control the image by variation of the sandwich time if you wish. Best results are usually obtained by adherence to the manufacturer's instructions.

The concept of diffusion transfer images has also been applied to the production of colour prints, and you will find such processes discussed in Chapter 13.

12 THE 'SINGLE FILM' APPROACH

You may be among the number of photographers who find it irksome to carry a variety of black-and-white films of different speeds. Perhaps you do this so as to be able to use the minimum speed of film suitable for any lighting conditions and hence benefit from the improved quality obtainable from slow emulsions.

Conventional monochrome films

Provided that you can use up a film on a subject of interest there is something to be gained from carrying and using a single type of film only. You can then manipulate development to achieve the appropriate effective film speed. This approach requires perhaps only one film but you may need to stock a considerable range of developers. For example, a fast negative film, normally rated at ISO 400/27° (ASA 400/27 DIN) may be developed in a fine grain developer to give better-than-normal quality but at an effective speed of only ISO 200/24° (ASA 200/24 DIN). The same film can also be developed for a range of times in a specially formulated developer which will yield effective speeds of from ISO 500/28° (ASA 500/28 DIN) to ISO 3200/36° (ASA 3200/36 DIN). You can expect the negatives developed to show an increasing loss of quality as higher speeds are achieved by prolonging the development. Even at ISO 3200/36°, however, the results should prove generally acceptable. This approach, using a fast film, is demonstrated in fig 12.1.

The range of effective speeds obtainable with low or medium speed films and the same range of developers is rather less but may, nonetheless, be useful. A low-speed film, rated at ISO 50/18° (ASA 50/18 DIN) can give a range of speeds from ISO 25/15° (ASA 25/15 DIN) to ISO 100/21° (ASA 100/21 DIN). A medium speed film, rated at ISO 125/22° (ASA 125/22 DIN) can give effective speeds of from ISO 64/19° (ASA 64/19 DIN) to ISO 320/26° (ASA 320/26 DIN). Of course, if you are desperate, you can grossly underexpose film and then use the approaches discussed in Chapter 8 to rescue some kind of record.

Chromogenic monochrome film

The advent of chromogenic black-and-white negative film, eg, Ilford XP1-400 and Agfapan Vario XL, has greatly simplified the single film approach. Even if you stock the required three developing solutions, each of the three film types mentioned can only give good quality over a range of a multiple of some five to six times in effective speed, or about 2½ stops. You may, therefore, find a single film of the conventional type to be rather cramping. The situation with chromogenic monochrome negative film is quite different and, typically, using the standard processing solutions and developing times, a range of speeds from ISO 50/18° (ASA 50/18 DIN) to ISO 1600/33° (ASA 1600/33 DIN) is possible.

12.1 A fast negative film rated from ISO 200/24° (ASA 200/24 DIN) to ISO 12800/42° (ASA 12800/42 DIN) by the use of different developer solutions: **A** Ilford Perceptol, ISO 200/24° (ASA 200/24 DIN), **B** Ilford ID-11, ISO 800/30° (ASA 800/30 DIN), **C** Ilford Microphen, ISO 3200/36° (ASA 3200/36 DIN), **D** Ilford Microphen, ISO 12800/42° (ASA 12800/42 DIN). The original prints were made at 5 x enlargement and it can be seen that the quality obtained by this range of exposures and developers was surprisingly good.

A

B

C

D

How chromogenic films work –
the nature of the image

An exposed chromogenic film requires two, specially formulated, processing solutions. The first, a developer, forms a silver image in areas where light has struck the emulsion. The chemistry is conventional:

Exposed silver salts + developing agent →
 silver image + oxidised developing agent + by-products.

The oxidised developing agent, which is an unwanted nuisance in conventional processing, then reacts with chemicals called *colour couplers*, already present in the emulsion, to form a dye image alongside the silver image:

Oxidised developing agent + colour coupler → dye image.

The silver image and unwanted residual silver salts are then removed using the second processing solution, a bleach-fixer or 'blix' or, alternatively, by using separate bleach and fix baths. The processes are shown for a typical chromogenic negative film in fig 12.2. All that is

12.2 Processing a typical chromogenic monochrome negative film. The process designed for the film is shown together with a typical, suitable, colour negative process.

Process	Ilford XP1		Kodak C-41	
	Temp (°C)	Time (min)	Temp (°C)	Time (min)
Pre-wet	40	1	–	–
Develop	38	5	37.8 ± 0.2	3.25
Bleach-fix	38	5	–	–
Bleach	–	–	24–40	6.5
Wash	35–40	3	24–40	3.25
Fixer	–	–	24–40	6.5
Wash	–	–	24–40	3.25
Stabiliser	–	–	24–40	1.5
Dilute wetting agent	rinse	–	–	–
Total time		14		24.25

42 A high speed film was required for this long focal length, hand-held, shot. This was achieved by up-rating Kodak Tri-X negative film from ISO 400/27° to 1600/33° using extended development in Kodak D-76. The negative, not being contrasty, was printed on grade 3 paper.

left in the film after the final wash is the dye image developed where the emulsion was exposed to light. This image is not usually neutral and may vary quite widely in colour from film to film without detectable adverse effects on the quality of prints made from the negatives.

Chromogenic films – properties of the image

If, to experiment, you deliberately overexpose a conventional black-and-white negative film, process in the normal way and then print the results, you will probably find that the over exposed negatives give grainy prints of rather poor definition. You will get a different result if you do the same thing with a chromogenic film. Fig 12.3 shows what happens. The negative rated at ISO 50/18° (ASA 50/18 DIN) gives less grain and a sharper image than the example rated at ISO 400/27° (ASA.400/27 DIN).

Interestingly, the dye image behaves quite differently from the silver image which generates it. The graininess of prints made from heavily exposed chromogenic negatives is actually less than that of the standard result, as you can see in fig 12.3.

You can therefore expose any frame of such a film at any speed rating within the range (which can be very wide) recommended by the manufacturer. All the negatives will be acceptable provided that the standard development procedure is carried out. This can be either in the solutions specially provided by the manufacturer or the Kodak C-41 process commonly used for de-

veloping colour negative films.

Generally, the graininess, in particular, of prints made from chromogenic negative film is lower than you would find for prints made from conventional negative film rated at the same speed. Also, if you use the single film approach with

43 Ilford XP-1 film rated at 400 ASA was used to record this side-lit subject. The high definition achievable with chromogenic processing is well illustrated by this image which has much fine detail.

chromogenic film, you get the high quality associated with low speed films when you overexpose, or under-rate a film. You only lose quality significantly with gross underexposure, or overrating, of the film. The range of speeds available with such a film is given in fig 12.4.

Chromogenic monochrome negative materials thus enable you to carry and use a single film suitable for speed ratings ranging from the equivalent of very fine grain to very high speed conventional negative films. And you only need one set of processing solutions and the standard time and temperature for each.

12.3 The variation of print quality with negative exposure level for a chromogenic black-and-white film: **A** Ilford XP1-400 rated at ISO 50/18° (ASA 50/18 DIN), **B** Ilford XP1-400 rated at ISO 400/27° (ASA 400/27 DIN). The processing was standard in each case and the prints are 20 x enlargements.

A

B

C

D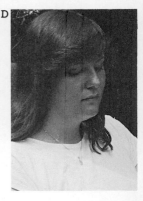

12.4 The single-film approach using a chromogenic negative film: **A** ISO 50/18° (ASA 50/18 DIN) 5 min development (standard), **B** ISO 400/27° (ASA 400/27 DIN) 5 min development, **C** ISO 800/30° (ASA 800/30 DIN) 7½ min development, **D** ISO 1600/33° (ASA 1600/33 DIN) 7½ min development, **E** ISO 3200/36° (ASA 3200/36 DIN) 8½ min development, **F** ISO 6400/39° (ASA 6400/39 DIN) 8½ min development. The prints are made at 5 x enlargement and the film was Ilford XP1-400 developed in its own chemicals (not the C-41 process).

E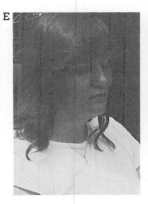

F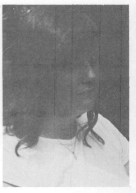

44 A rather low contrast scene taken on Ilford XP-1, a chromogenic material. The film was rated at 400 ASA and printed on grade 4 paper.

13 PENNY PLAIN, TUPPENCE COLOURED

Things have changed dramatically since the nineteenth century when toy theatre scenery sets came 'penny plain or tuppence coloured'. Nowadays colour photographs have become the norm for amateur and much professional work. It actually costs more to obtain a black-and-white print than a colour print from most photofinishing laboratories. In this chapter the relationship between black-and-white and colour images will be examined.

Toned monochrome images

Early monochrome silver photographic processes did not necessarily give a neutral image. Many gave warm-toned, sometimes sepia, results varying in hue through a range from red to brown. Those, and other image tones can also be obtained by aftertreatment, or toning, of the neutral silver images you are used to seeing today.

Traditional toning methods have involved either direct treatment of the silver image with suitable inorganic salts to achieve a (sometimes subtly) coloured result, or a preliminary bleaching stage followed by an inorganic salt treatment. Alternatively, you can treat the bleached silver image with a variety of organic chemicals to achieve a wide range of image colours.

A complete treatment of toning is outside the scope of this book but a few common, named toners are listed in fig 13.1 along with the colours they may yield. However, success with toning modern materials is by no means certain. You should test any candidate toner on a spare print made on the same type of printing paper before attempting to tone your special print. In some cases you will need to make the print lighter or darker than usual for the optimum toned image.

Some examples of toned monochrome images are shown in fig 13.2.

Chromogenic development

An alternative to the traditional toning methods is to make use of the chemistry of chromogenic development outlined in Chapter 12. You can bleach a conventionally developed and fixed silver image back to a silver salt (usually silver bromide) similar to that from which the image originally came. At this stage the emulsion contains silver salts only where the original image was developed.

13.1 Commonly used toners and their effects on a neutral silver image.

Name of toning process	Expected image tone, remarks
Sulphide	Sepia. Improves image permanence.
Selenium	Purple-brown to neutral. Improves image permanence.
Gold	Effect depends on the formulation, typically violet to blue-black. Increases image permanence.
Iron	Prussian blue.
Nickel	Magenta/red obtainable.
Uranium	Red to red-brown.

You may then treat the silver salts present with a chromogenic developer which contains a colour developing agent and a soluble colour coupler. The silver salts develop, ie, are chemically reduced, to form a metallic silver image and, at the same time and place, a dye image is also developed. The colour of the dye formed depends primarily on the colour coupler present and very little on the exact formula of the developing agent.

A range of suitable couplers gives yellow, magenta, red, blue and blue-green (cyan) dyes. You can view the dye image alone as the purest colour obtained provided that you bleach away the accompanying silver image. If the silver remains, then the colour is correspondingly darkened. Chromogenic development is thus able to tone silver photographic images and to provide a wide range of hues, particularly if mixtures of the colour couplers are used. Formulae suitable for bleaching a silver image and developing one formed from dye are shown in fig 13.3.

Full colour processes

Modern colour materials operate on the three-colour principle. The normal human eye detects colour by analysing the incoming light into relative amounts of red, green and blue light. The balance between these amounts is interpreted by the brain and the eye perceives a colour. Colour films are constructed, basically, with three light-sensitive assemblies, to analyse incoming radiation into red, green and blue content. Each of these primary colours is imaged in a separate emulsion assembly. Dye images are then generated in each and the dye colour is complementary to the sensitivity of each assembly in which it is formed.

13.3 Toning by chromogenic development of the rehalogenised silver image:

A Two rehalogenising bleaches.

	I	II
Iron sequestrene (Ciba-Geigy)	100g	–
Potassium ferricyanide	–	20g
Potassium bromide	50g	8g
Boric acid	–	5g
Borax	–	1g
Ammonia (20% solution)	6ml	–
Water to	1 litre	1 litre

Bleach I is similar to that used in the Kodak C-41 process, which would also be suitable. Bleaches which are not normally followed by fix baths are not suitable: they are probably bleach-fixers which would totally remove your original image.

B Chromogenic developer containing a coupler.

Proprietary colour developer (C-41, Ektaprint-2, XP-1 etc)	1 litre
Coupler*	1g

*Any of the following couplers may be used to achieve the colour indicated and should be dissolved in the minimum quantity of concentrated caustic soda solution before addition to the developer.

Couplers

1-naphthol	blue
2, 4-dichloro-1-naphthol	blue-green (cyan)
1-phenyl-3-methyl-5-pyrazolone	magenta
p-nitrobenzyl cyanide	red-magenta
Acetoacet-2, 5-dichloroanilide	yellow

Colour photography and colour vision both simplify the world of colour into a mix of redness, greenness and blueness. The image supplies to your eye the appropriate mixture of red, green and blue light to simulate the appearance of the subject of your photograph. The mixture is provided by using three dye images, each of which controls light of one primary colour. The colours used are shown in fig 13.4.

13.4 Primary colours and their control by photographic image dyes.

Primary colour	Complementary colour	Colour of image dye
Red	Blue-green	Cyan (blue-green)
Green	Red-purple	Magenta (red-purple)
Blue	Yellow	Yellow

A mixture of the correct proportions of red, green and blue light is seen as white light. Each complementary colour represents that white,

minus one primary colour. So, if the red light is subtracted you see a mixture of blue and green which, logically enough, appears blue-green. This is the colour that photographic and other scientists refer to as *cyan*. Because of the subtraction sum that relates primaries, white and complementaries, you will find that the latter are sometimes referred to as 'minus red' etc.

A cyan colour filter or dye image works by selectively absorbing red light, a magenta by absorbing green light and a yellow by absorbing blue light. All you need in principle for successful colour photography is the right combination of three image dyes in appropriate places in the film or paper emulsions.

Two major types of mechanism are used to give colour images by fairly conventional, wet, processing techniques. The chromogenic mechanism actually forms the image dyes during development. The silver-dye-bleach system selectively destroys pre-existing dyes during processing.

Chromogenic colour processes – negative-positive

By using chromogenic development, already described in this, and the preceding chapter, you can develop a cyan dye where red light has been imaged, and so on. The procedure is outlined diagrammatically in fig 13.5. Each sensitive layer responds to only one primary colour and a dye of the complementary colour is formed alongside the developed silver by reaction between oxidised developing agent and appropriate couplers incorporated in each emulsion layer. Subsequent bleaching and fixing, either separately or in combination, removes the black metallic silver together with the residual silver salts and leaves the dye image. When you do this you make a colour negative which records tones in a similar way to a monochrome negative but also carries colour information. You need a colour printing paper, also negative-working, if you are to decode the information by making a positive print from the negative.

In practice, colour printing papers have similar tone reproduction characteristics to those of monochrome papers. A low contrast negative is printed on a high contrast paper. The assembly of three colour-sensitive emulsions in a colour negative film is called an *integral tripack* and a similar structure is used for colour print materials – although the layer order may be different. The

13.5 How a colour negative works. The subject is shown together with the essential processing steps in making a colour negative for subsequent printing on colour printing paper. (See Figure 13.6)

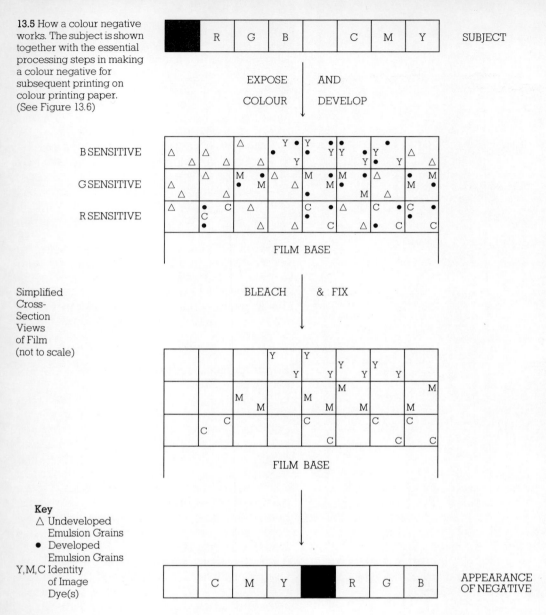

SUBJECT

EXPOSE AND

COLOUR DEVELOP

B SENSITIVE

G SENSITIVE

R SENSITIVE

FILM BASE

Simplified Cross-Section Views of Film (not to scale)

BLEACH & FIX

FILM BASE

Key
△ Undeveloped Emulsion Grains
● Developed Emulsion Grains
Y,M,C Identity of Image Dye(s)

APPEARANCE OF NEGATIVE

printing of a colour negative is shown in fig 13.6.

Developing a colour negative film requires processes similar to those described in Chapter 12 for chromogenic black-and-white film. Indeed, the Kodak C-41 process, shown in fig 12.2, for colour negative film has achieved near-universality for developing still (as opposed to motion picture) colour negatives and is frequently also used for chromogenic black-and-white film. Most major photographic manufacturers have aimed to make their colour negative films compatible with the Kodak process and

often make compatible chemicals, too. Additionally, a range of kits is available: these often simplify the processing to only two chemical baths and claim results comparable to those from the standard process. Sometimes, these kits are also claimed to be suitable for processing negative-positive colour paper. For large-scale work, specialist firms offer a range of bulk chemicals for colour-negative processing – widely used in photofinishing laboratories.

Colour papers used in negative-positive printing tend to be made compatible with

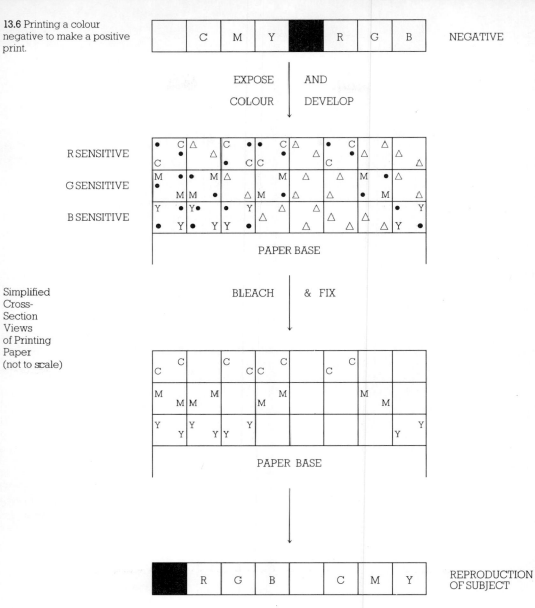

13.6 Printing a colour negative to make a positive print.

NEGATIVE

| | C | M | Y | | R | G | B | |

EXPOSE AND
COLOUR DEVELOP

R SENSITIVE

G SENSITIVE

B SENSITIVE

PAPER BASE

Simplified
Cross-
Section
Views
of Printing
Paper
(not to scale)

BLEACH & FIX

PAPER BASE

REPRODUCTION
OF SUBJECT

| | R | G | B | | C | M | Y | |

Kodak Ektaprint 2 chemicals. The process is illustrated in fig 13.7 and here only two chemical solutions are required, a chromogenic developer and a bleach-fix. Many manufacturers make compatible chemicals varying in size from small-scale amateur kits to bulk supplies for photofinishing laboratories.

Chromogenic colour processes – reversal
Just as for the black-and-white processes described in Chapter 7, you can make positive transparencies for projection by using a reversal

13.7 Processing negative-positive colour printing paper using Kodak Ektaprint 2 or compatible chemistry.

	Temp (°C)	Time (min)
Develop	33 ± 0.3	3½
Bleach-fix	30–34	1½
Wash	30–34	3½
Total time		8½

process for colour film. With colour processes, however, the significant differences between negative and reversal films lead them to be designated as 'for prints' and 'for slides'. You buy

a colour film after deciding whether you want prints or slides. The processing sequence for colour reversal films resembles that for black-and-white films except that for the colour process things are a little simpler. When colour processing you do not bleach the film between first and second development stages because only the second is a colour developer and all silver is to be removed after the second development anyway.

Internationally, most manufacturers have standardised on compatability with Kodak E-6 chemistry and such processes have the sequence listed in fig 13.8. The essentials of this process are shown diagrammatically in fig 13.9 from which it can be seen that the first stage is to develop the exposed emulsions to give a black-and-white negative. To make them developable, you then treat the remaining undeveloped silver salts by chemical fogging, and develop them in colour developer. The result is a very black film containing a set of black silver negative and positive images, together with the positive dye record that you want to see. As you do not want the silver images, you bleach the film to form silver salts from the unwanted silver, and then fix all the silver salts away. When you view the final result you see a positive colour record of the original subject. This is the positive colour transparency you wanted when you took the photograph.

13.8 A widely used reversal colour process for the production of colour slides. Kodak E-6.

	Temp (°C)	Time (min)
First developer	38 ± 0.3	6
Wash	25–39	2
Reversal bath	33–39	2
Colour developer	38 ± 0.6	6
Conditioner	33–39	2
Bleach	33–39	6
Fixer	33–39	4
Final wash	20–30	6
Stabiliser	ambient	0.5
Total time		34.5

Sometimes, however, it does not stop at the transparency – you may want a colour print. There is a variety of methods of making such prints. Professional laboratories may first make a special colour negative or 'internegative' from the transparency, using a film designed for the purpose. The internegative can then be printed on conventional negative-positive colour paper and by this means very good prints are obtain-able. Most photographers do not make internegatives themselves because the material is unique and its exposure and processing are rather critical. The work is best left to the specialist who has acquired skill through experience of using the process regularly.

You can, however, make very successful colour prints from transparencies by the various reversal print processes available. While most of these are chromogenic processes a silver-dye-bleach system is also marketed.

Chromogenic reversal colour paper, like all the colour materials described so far, is an integral tripack material and is coated on a polyethylene-laminated paper base. A typical processing sequence for such a paper is listed in fig 13.10. The basic mechanisms involved are similar to those for the reversal film illustrated in fig 13.9. You will see from fig 13.10 that one difference between the film and paper processes is that, in the latter, you use a re-exposure to light in order to make developable the undeveloped silver salts remaining after first development. A number of manufacturers make such reversal colour papers and, once again, the tendency has been to make chemicals and sensitive materials compatible with a Kodak process, in this case Kodak Ektaprint R-14 chemicals, or the later Ektaprint R-3 process.

Silver-dye-bleach process

An alternative for producing colour prints from colour transparencies is the silver-dye-bleach process. At present only Cibachrome materials are commonly available and all details given therefore refer to this process. The print materials are available coated on polyethylene laminated paper, pigmented white reflecting film and transparent film bases.

The most significant difference between chromogenic and dye-bleach print materials is that the former contains colour couplers and *forms* the image dyes during development, the latter contains the image dyes to start with and these are selectively *destroyed* during processing to form the image. The processing is therefore different from that of chromogenic materials. In particular, a rather special bleach solution is used. The processing sequence is shown in fig 13.11 for a silver-dye-bleach process and this is illustrated diagrammatically in fig 13.12.

The first step, black-and-white development, is quite conventional and uses an active developer

13.9 How the reversal colour process works. The subject is shown as well as the essential steps in making a colour transparency.

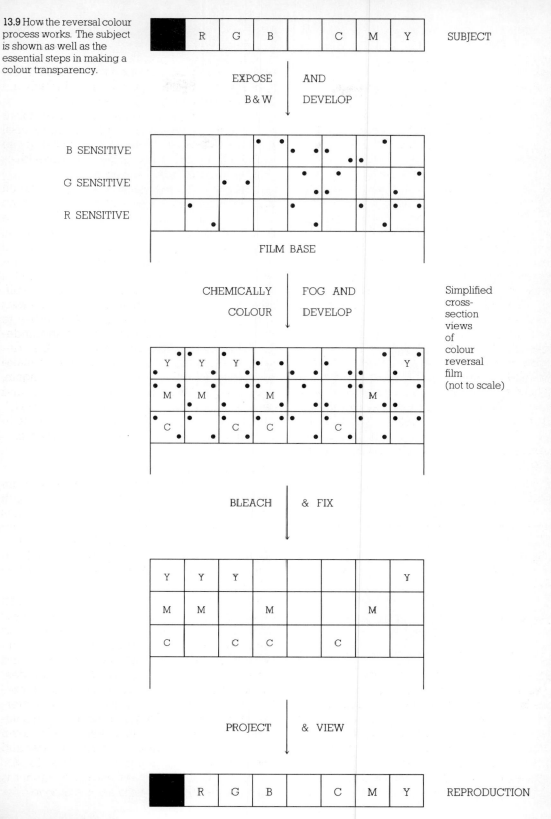

SUBJECT

EXPOSE AND
B & W DEVELOP

B SENSITIVE

G SENSITIVE

R SENSITIVE

FILM BASE

CHEMICALLY FOG AND
COLOUR DEVELOP

Simplified cross-section views of colour reversal film (not to scale)

BLEACH & FIX

PROJECT & VIEW

REPRODUCTION

13.10 A typical reversal colour paper process designed for a replenished tank line.

	Temp (°C)	Time (min)
Presoak	30–31	4
First developer	30 ± 0.3	3.25
Wash	28–35	4.5
Re-exposure		(0.25)
Colour developer	30 ± 0.3	3
Wash	28–35	1.5
Bleach-fix A*	30 ± 0.3	1.5
Bleach-fix B*	30 ± 0.3	1.5
Wash	28–35	5
Total time		24.5

*If a discard system is used a single 3 min bleach-fix step may be used.

13.11 A silver-dye-bleach process for making colour prints from colour transparencies.

	Temp (°C)	Time (min)
Develop	24 ± 1	3
Rinse	24	0.5
Bleach	24	3
Fix	24	3
Wash	24	3
Total time		12.5

This processing sequence is for Process P-30. Other conditions apply to different Cibachrome processes.

to give a negative silver image. The heart of the process lies in the bleach bath which not only bleaches the silver image but, at the same time and in the same place, also destroys the adjacent dye present in each emulsion layer. The final fixing-bath removes all the unwanted silver salts leaving the final positive dye image.

Self-developing colour processes

At least three colour processes are currently available in which, after making the camera exposure, you obtain either a sandwich of material to peel apart after a (short) recommended time, or a single sheet of material in which a full-colour image slowly appears over a period of minutes. The Polaroid company manufactures materials of both types while a Kodak system is available which involves no peeling apart and discarding of a sensitive material.

In each manufacturer's process, a diffusion of the image dyes into a receiving layer takes place but the chemical mechanisms involved differ between Polacolor and the Kodak Instant Print processes.

The first of such self-developing materials was introduced by Polaroid and uses a nearly conventional tripack construction for the sensitive

emulsions. Instead of chromogenic development, however, a clever use is made of black-and-white development.

In each of the three sensitive emulsion assemblies (fig 13.13) there are appropriate complementary-colour dyes, but each dye molecule is permanently linked to a black-and-white developing agent to form what Polaroid call a 'dye-developer' molecule. Under acid or near-neutral conditions the entire dye-developer molecule is anchored by the developer part, which is neither mobile nor photographically active. After exposure, the emulsions are made alkaline by the activator solution contained in a pod and spread as it leaves the camera. The developer part of the molecule then becomes both mobile and active. When the dye-developer encounters adjacent exposed silver salts, development occurs and the developer part becomes immobile and inactive once more. Where development does not take place (because there are no exposed grains) the dye-developer remains mobile and diffuses to a receiving-layer – either held in contact in a sandwich (fig 13.13) or another integrally coated layer (fig 13.14). Chemicals called *mordants* within the receiving layer immobilise the dye part of the dye-developer molecules which are therefore trapped, building up the positive colour reproduction which is required. After the positive image has been adequately formed, a *timing* or controlling mechanism in the assembly returns the material to near-neutrality and all the chemical reactions are over. The desired image is stable and no further changes should take place.

The Kodak Instant Print system uses unconventional direct-positive emulsions in a tripack configuration. On leaving the camera, activation causes direct positive black-and-white development to take place. The oxidation products of development react with adjacent molecules called 'dye-releasers' to release the mobile dye parts of the molecules. The dyes then diffuse to a mordanting layer where they become immobilised and build up the required positive colour image. The process is shown in fig 13.15.

The detailed chemical mechanisms of these processes are quite complicated and their consideration lies beyond the scope of the present book. If you are interested, you should look up such processes in more technical works on the photographic process (page 149).

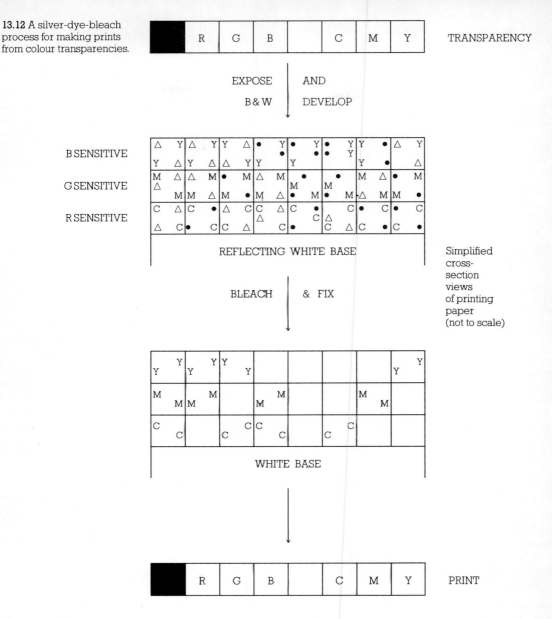

13.12 A silver-dye-bleach process for making prints from colour transparencies.

TRANSPARENCY

EXPOSE AND

B & W DEVELOP

B SENSITIVE

G SENSITIVE

R SENSITIVE

REFLECTING WHITE BASE

Simplified cross-section views of printing paper (not to scale)

BLEACH & FIX

WHITE BASE

PRINT

'Instant' printing materials and processes

It might be thought that a book concerned with photographic developing need not even mention the self-developing instant photographic processes. This would possibly be true if the only examples of these processes to be found were camera materials. Recently, however, there has been a tendency to apply the diffusion-transfer technology of the camera materials to developing colour prints. You can use these processes to make colour prints from transparencies alone (Agfachrome Speed) or from either negatives or positives (Kodak Ektaflex).

The Agfa system is so designed that once you have made the printing exposure all you have to do is to immerse the material (in the dark) in a strongly alkaline activator solution for 1½ min at a temperature of 18 – 24°C (64 – 75°F). The activation stage is followed by a 5 min wash. So, some 6½ min after exposure you can look at a wet but fully processed print from the transparency of your choice. You can, to some extent, control the overall contrast of the Agfachrome Speed print by manipulation of the activator composition. You ob-

| | R | G | B | | C | M | Y | SUBJECT |

POSITIVE (RECEIVING) MATERIAL

PAPER BASE

ACID LAYER

TIMING LAYER
MORDANT LAYER

ⓜ ⓜ ⓜ ⓜ ⓜ ⓜ ⓜ ⓜ

ACTIVATOR (ALKALINE)

NEGATIVE MATERIAL

△	△	△	•	•	•	•	△	B SENSITIVE
Y-D	Y-D	Y-D	Y-D	Y-D	Y-D	Y-D	Y-D	Y DYE-DEVELOPER / SPACER
△	△	•	△	•	•	△	•	G SENSITIVE
M-D	M-D	M-D	M-D	M-D	M-D	M-D	M-D	M DYE-DEVELOPER / SPACER
△	•	△	△	•	△	•	•	R SENSITIVE
C-D	C-D	C-D	C-D	C-D	C-D	C-D	C-D	C DYE-DEVELOPER

BASE

PART OF THE POSITIVE MATERIAL

| C-D M-D Y-D | M-D Y-D | C-D Y-D | C-D M-D | | C-D | | M-D | | THE TRAPPED DYES |
| | | | | | | | Y-D | |

VIEW ↑ THIS SIDE

| | R | G | B | | C | M | Y | REPRODUCTION |

13.13 The 'peel-apart' Polacolor system. The film and paper sandwich is shown after rupture of the activator pod and ejection from the camera. When dye-developer transfer is complete and the molecules have been trapped, the receiving material is shown and also the final appearance of the reproduction.

KEY TO SYMBOLS
ⓜ MORDANT
wwwww ACID MOLECULE
C-D, M-D, Y-D DYE-DEVELOPER

tain a lower contrast by the addition of potassium bromide to the solution, while you can use a simple water addition to raise the contrast.

The Kodak Ektaflex system comprises a small manually operated processing machine (fig 13.16), negative and positive light-sensitive films, an insensitive paper and an activator solution. The activator solution is present in the machine when this is in use. When you have exposed a sheet of either the negative or positive film the machine is used to soak the film in activator for 20 sec and then to squeeze it firmly against the Ektaflex paper and to eject the sandwich. The sandwich remains intact for about 8 min, depending on the room temperature, which should be between 18 and 27°C. After the appropriate time has elapsed you peel apart the two halves to reveal the colour print which is still wet but needs no washing. You then discard the exposed film material and dry the print.

Both the 'instant' print processes described are developments which offer increased conveni-

8.7 Forced processing of a colour reversal film. The only hope of catching any of the action in this circus was to rate the film at ISO 6400/39° and then to grossly extend the first development stage. A separate experiment with another, similar, film was carried out before hazarding the circus photographs. Under the circumstances, any readable image seemed a miracle so the loss of quality involved in the forced process did not seem disastrous (see Chapter 8).

13.2 One of the commonest forms of toning is that giving a sepia image. The actual hue can range between dull maroon and yellowish brown, depending on the method used. Such toning can give a print 'atmosphere' and often an impression of age. Toning can also improve the long-term stability of the image (see Chapter 13).

45 All the colours in conventional full colour photographs are made from cyan, magenta and yellow dyes in various proportions. These three colours are seen together with red, green and blue formed by combinations of the dyes.

46 Modern colour processes can give you excellent photographs of quite subtle subjects. Here, stress is laid on quite minor colour changes in the rock for the overall visual effect.

47 Primary colours can be particularly arresting. In this case the vivid red has been well recorded by a print on Ilford Cibachrome silver-dye-bleach material, made from a Kodak Kodachrome transparency.

	R	G	B		C	M	Y

SUBJECT

PAPER BASE

TRANSPARENT FILM

POSITIVE SECTION

ACID LAYER

TIMING LAYER
MORDANT LAYER

ACTIVATOR (ALKALINE)
CONTAINS WHITE PIGMENT

NEGATIVE SECTION

Y-D	Y-D	Y-D	Y-D	Y-D	Y-D	Y-D	Y-D

B SENSITIVE
Y DYE-DEVELOPER
SPACER
G SENSITIVE

M-D	M-D	M-D	M-D	M-D	M-D	M-D	M-D

M DYE-DEVELOPER
SPACER
R SENSITIVE

C-D	C-D	C-D	C-D	C-D	C-D	C-D	C-D

C DYE-DEVELOPER

OPAQUE BASE

VIEW

↓

POSITIVE SECTION AFTER DYE-DEVELOPER TRANSFER

THE TRAPPED DYES

WHITE BACKGROUND

	R	G	B		C	M	Y

REPRODUCTION

48 A number of colour printing systems are suitable for 'one shot' or 'total loss' processing. This print was made from a Kodak Ektachrome transparency using a three-solution Ilford Cibachrome process. Negative-positive processes usually need only two solutions for developing the print.

49 Positive-positive colour prints tend to have high contrast. In this Cibachrome print from an Ektachrome transparency the increased contrast emphasizes the luminous mist and the gloomy foreground.

13.14 The Polaroid SX-70 process. The material is shown after exposure and ejection from the camera. When dye-developer transfer is complete chemical reactions within the material cease and the dye image is viewed through the face of the film that received the camera exposure.

KEY TO SYMBOLS
X WHITE PIGMENT

13.15 Kodak Instant Print process. The material is shown after exposure and removal from the camera. The direct-positive emulsions release dyes on development and these dyes diffuse to the mordant layer where they are immobilised to form the final image which is viewed against a white opaque background.

| | R | G | B | | C | M | Y | REPRODUCTION |

VIEW THIS │ SIDE

TRANSPARENT SUPPORT

| ⓜ | ⓜ | ⓜ | ⓜ | ⓜ | ⓜ | ⓜ | ⓜ | MORDANT LAYER |

WHITE OPAQUE LAYER

BLACK OPAQUE LAYER

C-R	C-R	C-R	C-R	C-R	C-R	C-R	C-R	C DYE RELEASER
•	△	•	•	△	•	△	△	R SENSITIVE
M-R	M-R	M-R	M-R	M-R	M-R	M-R	M-R	M DYE-RELEASER
•	•	△	•	△	△	•	△	G SENSITIVE
Y-R	Y-R	Y-R	Y-R	Y-R	Y-R	Y-R	Y-R	Y DYE-RELEASER
•	•	•	△	△	△	△	•	B SENSITIVE

UV ABSORBER
ALKALINE ACTIVATOR
TIMING LAYERS
ACID LAYER

TRANSPARENT SUPPORT

EXPOSURE ↑ THIS SIDE

13.16 The Kodak Ektaflex Printmaker machine and the activator solution required. The machine is manually operated and can handle prints up to 20.3 x 25.4 cm (8 x 10 in) in size. The 2.84 litres (5 pint) bottle of activator processes up to 72, 8 x 10 in prints.

| | R | G | B | | C | M | Y | SUBJECT |

ence, but at a rather higher cost when compared with more conventional processes.

Practical approaches to colour processes

You can, with care, carry out the toning processes described in this chapter using simple equipment, particularly processing dishes. Temperatures should be about 20°C (68°F) in most cases but are usually not critical. If looking up recipes for toners and making up the solutions from individual chemicals does not attract you, then the proprietary ranges of toner solution may be useful to you. These are generally quite easy to use and should give you all the necessary instructions for the desired results to be obtained.

Once you have decided to carry out your own full-colour processing you must review your processing equipment to make sure that it is suitable. The equipment and procedures for black-and-white processing described in Chapters 2 – 4 are a good start for colour processing but control of the temperature is much more critical with colour. You can process small quantities of 35mm and 120 colour film quite conveniently in spiral tanks and larger quantities in 15 13.5 litre tanks using spirals held in racks, provided that the solutions are replenished carefully or discarded after use. Larger-scale work, typical of processing laboratories, can be carried out

with versatile processing machines designed to cope with a range of processes, or even larger-scale equipment dedicated to a single process.

The most versatile equipment is that based on a rather simple design widely used with 'one-shot' or 'total-loss' chemicals which are discarded immediately after use. The material to be processed is loaded either inside a drum, fitted into spirals or other holders, or stretched round the outside of a cylindrical or skeletal drum. The drum is then closed up to prevent light getting in or, particularly with the skeletal type, placed in a light-tight enclosure. Various methods of temperature control are used, varying in complexity from the 'drift by' method outlined in Chapter 3 to automatic thermostatic control of solution, wash water and air temperatures in an enclosed machine. Examples of these processing machines are seen in fig 13.17.

An alternative, suitable for medium scale colour processing, is the use of roller-transport machines. These are similar to the type used for black-and-white film described in Chapter 2 and illustrated in fig 2.9. One advantage of such machines is that a variety of film sizes can be handled and solution volumes can be quite low. They are suitable, in different sizes, for both colour films and colour printing papers and are widely used in professional processing laboratories and large photographic units.

For large-scale work in which a variety of film sizes must be processed the most popular equipment is probably the 'dip and dunk' machine, an example of which is shown in fig 13.18. In such machines, racks are used to hold the films vertically and are lowered by the machine into the first bath. Each bath is agitated by pumped circulation of the solutions and, usually, by bubbles of nitrogen

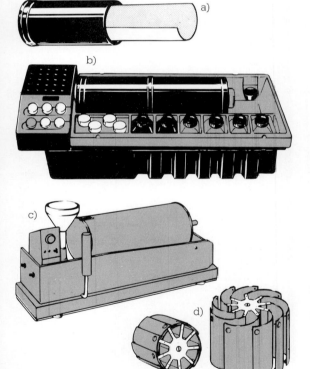

13.17 Common drum processors. In each case the drum is in contact with temperature-controlled water. **A** Removing a print from a typical drum,

B Colour processor using a drum for colour processing, **C** Drum processor, **D** Inserts for a drum to carry up to nine prints.

13.18 A 'dip and dunk' processing machine suitable for all sizes of colour film for which the necessary racks are

available (Durst ACS 54). This machine will process up to 54, 35mm films per hour.

injected at the bottom of each tank. For solutions other than developers it is quite feasible to use compressed air for agitation and this is, in fact, beneficial to a number of bleach baths. At a time interval determined by the machine design and the process being operated, the racks of film are lifted clear of the processing solutions and advanced along the line of tanks by a set distance interval. There may be more than one rest position for a rack in a particular bath, the duration of a particular stage being set by the machine cycle time and the number of rest positions. Any film size can be accommodated in such a machine provided that a rack exists for it. Consequently, these machines are popular in laboratories which have to accept a range of film formats for processing.

The largest scale of processing, typified by that for 35mm motion picture work, involves only one format of film. The film is fed continuously through the processing solutions at high speed. The processing time in any bath is determined by the path-length of the film, guided on pulleys through the solution, and the machine speed. Agitation in such machines depends on very vigorous pumped circulation of the solutions, often impinging on the film surface.

Probably the most obvious difference between the equipment for black-and-white and colour processing is the near absence of dishes for the latter. Generally, a dish is not used even for colour prints made on a one-off basis. The reason lies in the difficulty of controlling colour processing carried out in dishes. If you do use dishes you have problems in the maintenance of solution temperatures, aerial effects and the standardisation of agitation. All these problems can be minimised by a suitable drum processor. The solutions are commonly discarded after use to keep chemical effects to a minimum. Simple drum processors are shown in fig 13.17.

You can choose from a wide variety of equipment suitable for colour processing according to your scale of work. The most crucial points are control of temperature, composition of solutions and agitation. Colour processes can be very critical in these respects, and if control is deficient in any way you can spoil a large number of films or prints.

14 GRAPHIC EFFECTS

The title of this chapter has been chosen to indicate a range of photographic processes designed to give results resembling those used in the graphic arts. These often involve a simplification or elimination of tonal values other than black and white, and a concern with the design elements of shape, texture and sometimes colour.

Elimination of tone

You can, to some extent, eliminate tones by making high contrast prints using, for example, grade 5 printing paper. There will, however, still be some remaining intermediate tones. You will need special films and developing procedures to obtain the complete tone elimination typical of reproduction by lithography or letterpress – mechanical printing processes.

You can achieve the most complete photographic tonal elimination by using lith (short for lithographic) film and its specially formulated developer. The films, of which there is quite a variety, are available in most sizes from bulk 35mm to very large sheets. The emulsions are either panchromatic or orthochromatic. Unless you really need panchromatic reproduction you will find the orthochromatic varieties more convenient, as you can handle them under red safelights. For camera use you can, typically, rate such films at ISO 6/9° for the ortho- and ISO 32/16° for the panchromatic varieties.

It is probably best to carry out some tests to find the appropriate speed rating for the conditions in which you are working.

The recommended development for lith films is in the special developers produced for the purpose by the film manufacturer. The combination of film and developer causes *infectious development* in which the growth of image density is strongly accelerated by the presence of developed silver. This gives the very high contrast shown in fig 14.1. If you use the ortho film and a red safelight you can watch individual tones suddenly develop to black in the order of most-exposed areas first, then mid-tones and finally the least-exposed areas. (If the least-exposed areas develop to black you have either over-exposed or overdeveloped the film.) The development time is normally around 3 min at 20°C (68°F) with constant agitation. The developer is rather alkaline and has a short life in the dish. It

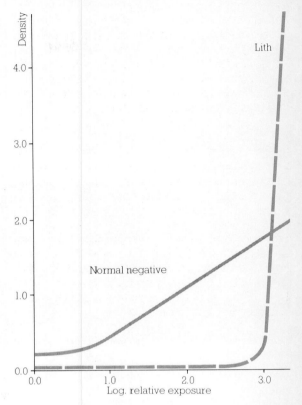

14.1 Comparison between a normal full-tone black-and-white negative film and a lith film. The latter is considerably slower but of much higher contrast.

is usually prepared in two parts and equal volumes are mixed in the dish immediately before use.

When the solution becomes yellow-to-brown it should be discarded and a fresh mixture made up.

Depending on the starting point, original scene or negative, you may go through one or two lith stage(s) before making a final positive print. Lith positive intermediates can be made by contact or projection printing lith negatives on to similar film material. A lith reproduction with virtually complete tonal elimination is shown in fig 14.2, a totally black and white result. This was prepared by making a lith positive from the camera negative and then a lith negative from that lith positive. Finally, the lith negative was printed on conventional bromide printing paper.

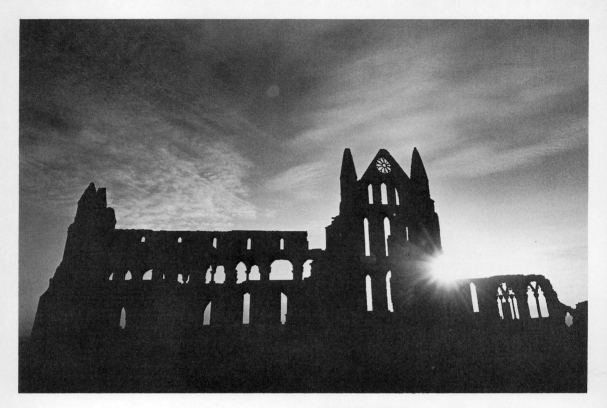

50 Graphic effects usually require the elimination of tonal information, reducing the impression of the image to two dimensions. In this print the Abbey appears in silhouette.

14.2 Tone elimination by the use of lith film and its appropriate developer to prepare intermediate positive and negative records from the full-tone camera negative.

Lith development

The special feature of lith development is its infectious nature. This is encouraged by using hydroquinone as the developing agent. Hydroquinone oxidation products catalyse the development of adjacent grains provided that the concentration of sodium sulphite, and hence free sulphite, is kept to a low level. In order to control the low concentration of sulphite, lith developers have been formulated using an aldehyde bisulphite compound which maintains, by dissociation, the concentration of sulphite at the required level.

The required caustic environment is often achieved by formulations such as that shown in fig 14.3 in which an aldehyde (usually formaldehyde or paraformaldehyde) reacts with sulphites or bisulphites in solution to give a hydroxide:

Formaldehyde + sodium sulphite + water →
 formaldehyde/bisulphite compound + sodium hydroxide.

Because of the nature of lith development, if you use ortho materials, you will find it possible to monitor development visually. Development times are often quoted with the intention of using 'development by inspection' within some range so you should base your decision on the visual appearance.

Nowadays, the printing industry often uses automatic machines for processing lith film. The machines are of the roller-transport type, illustrated in fig 2.9, and a special replenished-chemical system is used which avoids the instabilities of the caustic formulations shown in fig 14.3.

14.3 Formulae for two lith developers. The first is a single solution while the second is in two parts.

Single-solution type (Kodak D-85)

Sodium sulphite (anhydrous)	30g
Paraformaldehyde	7.5g
Potassium metabisulphite	2.6g
Boric acid	7.5g
Hydroquinone	22.5g
Potassium bromide	1.6g
Water to	1 litre

Two-solution type

Part A	Hydroquinone	30g
	Sodium formaldehyde bisulphite	100g
	Water to	1 litre
Part B	Sodium carbonate (monohydrate)	139g
	Sodium bicarbonate	45g
	Potassium bromide	1.5g
	Sodium sulphite	2.5g
	Water to	1 litre

Mix equal volumes of A and B for use.

Other high contrast processes

For many purposes, the extremely high contrast of lith processes (a gamma of about 10 is not unusual) may not be necessary, or even desirable. You can use a variety of such processes, often based on films having fine-grain chlorobromide emulsions specially made and often described as 'line' films. Very high contrast developers are required and these are usually of the type quoted in fig 9.4.

You can develop inherently high contrast emulsions of the lith and line types in less specialised developers and still obtain contrast high enough for many creative purposes. You can, for example, use a print developer (fig 7.1) to obtain a high contrast with relatively little development of unexposed grains (fog). Developers

designed for processing conventional films may give too much fog and are best avoided. They also tend to give rather low contrast. Typical results are shown in fig 14.4.

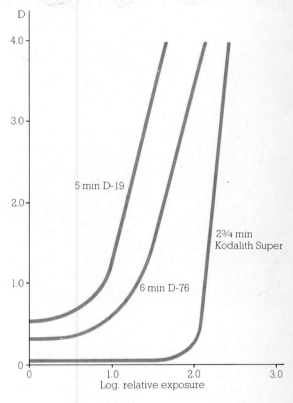

14.4 Development of lith film in a range of developers. The highest contrast results with the lowest fog level were obtained using the developer appropriate to the film.

Colour

If you require a colour image, high contrast records can be bleached and developed in a chromogenic developer containing a colour coupler, as described in Chapters 12 and 13. The paper base tends to pick up a stain from such developers, most noticeable in the highlight areas. This can be avoided by using resin-coated printing paper. An alternative, and very successful, approach to the graphic use of colour is the bleach-etch process.

Bleach-etch process

A range of black-and-white printing papers is available from at least two manufacturers, in which the undeveloped areas are coloured and

not white. The colours produced by various dyes coated with the emulsion on the paper base. You can obtain high contrast, black silver images on such papers with the image seen against a range of vivid colours, according to the product you use (fig 14.5).

The bleach-etch process is carried out using a high-contrast lith or line film intermediate which you then print on the tinted printing material. After printing, to get a maximum black image you develop the paper fully in a conventional print developer and fix it using a non-hardening fixer, such as a solution of plain hypo. Wash the print for a few (perhaps 2) minutes, and then immerse it in a bleach bath containing: copper (cupric) chloride to bleach the silver, acetic acid to control acidity, and hydrogen peroxide which causes a softening of the gelatin in image areas. The formulae are shown in fig 14.6. The silver image usually disappears quite quickly but immersion for double the bleaching time is generally recommended. Immediately after the bleach stage you place the print in water at 40°C (104°F) and swab the emulsion surface with a squeegee or cotton wool or even a soft paintbrush. The softened gelatin is removed from the paper base and the dye comes with it. You will then see a clear white area in place of the black silver image and the original dye colour where silver was not developed. A final wash is then required. The tonal rendition is reversed by the bleach-etch treatment and you should bear this in mind when making the lith intermediate that you intend to print in this way. An example of a print prepared by the process is shown in fig 14.7.

Another way to exploit this process is to make the final print, still from a lith intermediate, on a conventional resin-coated printing paper. The process is carried out as already described and a final treatment is given using a solution of a domestic food or cold-water fabric dye that is absorbed by gelatin. You will probably need to experiment with such dyes. They give coloration

14.6 A bleach solution for the bleach-etch process.		
Part A	Cupric chloride	10g
	Acetic acid (glacial)	50ml
	Water to	1 litre
Part B	Hydrogen peroxide (20 volume)	100ml
	or hydrogen peroxide (10 volume)	200 ml

Mix A with B immediately before use.

NB '10 volume' or '20 volume' hydrogen peroxide is a measure of the concentration of the hydrogen peroxide in commercially available solutions.

CAUTION The chemicals used in the solutions described here are harmful. Avoid skin contact by wearing rubber gloves. If you do get chemicals on your skin, wash them off immediately. If you get chemicals in your eyes, flood them with water immediately, continue for fifteen minutes and then seek medical attention. If you swallow chemicals it is generally useful to drink milk or water immediately and then to seek medical attention.

where gelatin is present, but none where the silver image and gelatin have been removed.

Permissible variables

When you carry out any creative darkroom techniques using graphic-arts processes it is important to know what you can get away with, that is, how tolerant the process is. Lith development, for example, is normally carried out using ortho materials so you can, if necessary, develop by inspection. This helps you to get the combination of exposure and development just right but should not be used as a substitute for control of exposure, developer composition and temperature. This is vital if you ever seek to repeat an effect. It is very important to replace lith developer with a fresh supply at frequent intervals.

On the other hand, the entirely subjective nature of the exercise frees you from considering the 'correctness' of the result. You should create the image you want by experimentation. If it satisfies you, then you have got it right.

51 Photographs which you treasure, perhaps to remind you of a person or an event, deserve to be made as stable as possible. You can usually wash out de-stabilizing chemicals from film or resin-coated paper based materials quite quickly. Fibre-based prints need longer washing for optimum stability.

15 NOTHING IS FOR EVER

Although you may create a photograph that you feel should live for ever, without taking care even the best can be surprisingly fugitive. Black-and-white and colour images both suffer from long-term changes with storage or display.

Black-and-white records
Both black-and-white negatives and prints conventionally comprise a black silver image in gelatin supported on a suitable base material, glass, film, resin-coated paper or fibre-based paper.

Problems with silver
Negatives and prints can, in the course of time, change and become patchy in appearance for two main reasons: inadequate fixing, and atmospheric effects. The first, which normally happens sooner, results from the effect of unwanted chemicals left in the emulsion after processing. In particular, the presence of residual hypo (sodium thiosulphate) or its silver salts leads to a bleaching, sometimes a yellowing, of the neutral silver

image. When printed, this shows up as patchy areas of high density in the print and completely ruins your photograph.

The obvious ways of avoiding this problem are to be careful not to over-use fixing solutions and also to try to reduce the amount of residual hypo to insignificant levels. This can be done by giving films an adequate washing time or by the use of a proprietary hypo eliminator between fixing and washing. Such solutions are available commercially as *washing aids*. Alternatively, a 2 per cent solution of sodium sulphite may be used. In each case, a short wash after fixing is followed by some five to ten minutes' treatment in the washing aid and a further five to ten minutes' wash in running water before drying.

Atmospheric effects
Black-and-white silver images are also subject to atmospheric attack in urban and, especially, industrial areas, where gases containing sulphur may be present in concentrations high enough to cause characteristic fading or browning of the image. Particularly in prints, a brownish mirror-like surface may appear. This is sometimes called *bronzing*.

Additional treatments
To avoid such atmospheric effects it is possible to protect negatives by an impermeable lacquer. It is also important to keep the storage conditions as dry and free from atmospheric pollutants as possible. For this reason prints should be dry-mounted avoiding water-absorbing gums and glues.

Other traditional methods of stabilising silver images have generally relied on toning the image. Toning with a noble metal, such as gold, has been widely employed to stabilise prints and also to alter the image tone (Chapter 13). The metal is unlikely to react chemically on storage and it can also protect the silver content of the image. Alternatively, the silver image can be converted to silver sulphide or silver selenide, neither of which is subject to attack by atmospheric impurities. The image tone usually changes to a brown or sepia colour with sulphide toning, and to a warm purplish neutral with selenium. Of the available methods, gold and selenium toning appear to be the current favour-

ites for giving long life to photographic prints.

Special care is needed to achieve a permanent image. You should carry out fixing in solutions that have not been overworked, and are not therefore loaded with silver salts. You must always wash film and paper images efficiently and use a washing aid as described above to remove residual fixing salts. It is only worth considering toning treatments to improve image permanence if all the other processing stages have been carried out properly first.

Dye images

In addition to the hazards of residual hypo or silver complexes which you encounter with black-and-white materials, the dye images in colour and chromogenic monochrome pictures are also prone to tiresome instabilities. These fall into two distinct classes: light- and dark-fading.

Light-fastness

Dye images work and are made visible by their absorption of visible light. They will generally also absorb ultra-violet radiation. The absorbed radiation, whether visible or ultra-violet, causes fading of the dyes and also, in some cases, a straining of the low density regions – the highlights in prints. Such effects occur during the projection of transparencies, the printing of negatives and the display of prints or large transparencies. You may find that prints on display change in apparent colour balance, sometimes differently at different density levels, and that a yellowish stain may spoil the whites.

Unlike silver images there is little that you can do to stabilise dye images. You should rigorously obey the manufacturer's recommendations for processing to ensure that unwanted chemicals are washed out thoroughly. Beyond that, you can perhaps avoid displaying prints under intense illumination for extended periods. The results of two months of display of colour prints in a south-facing window are shown in fig 15.1. From these it can be seen that modern colour prints are not very fugitive under these quite rigorous conditions. So you need not worry unduly about the results of displaying your prints under normal room lighting. As a matter of principle, however, you should try not to expose your precious prints to direct sunlight for longer than needed for casual examination. Your negatives and transparencies should never be left lying around where they can be illuminated by the sun.

A number of commercially made print lacquers are claimed to reduce print fading by absorbing ultra-violet radiation that would otherwise destroy the image dyes. You may find such treatments helpful but they usually alter the appearance of prints by increasing the yellowness, particularly of whites, and by modifying the surface texture. If you intend to use such a lacquer you should try some on a less important sample print first to see if you like the visual effect. Such lacquers cannot, in any case, give protection against fading caused by visible light.

Album stability

Under dark storage or album conditions a number of chemical reactions can take place and slowly destroy the image dyes. From time to time you will find league tables of image-stability published in magazines. These data generally indicate that colour materials of the Kodachrome type, which contain no residual colour-forming chemicals are superior in this respect to other dye-forming systems. A figure of some fifty years has recently been quoted as the expected life for Kodachrome transparencies. All other types of colour-developed materials seem markedly less good.

Over a long period of time the residual chemicals inevitably present in most chromogenically developed materials are capable of attacking image dyes. Other, rather slow, reactions involve acidity or alkalinity (ie, the pH of the material) and the water content. The manufacturer tries to minimise the residual chemical problem but you also have to play your part. The best compromise pH value will be achieved and residual hypo and silver complexes minimised if you process materials correctly. You can then further reduce fading reactions by choosing dry and preferably cool storage conditions.

Other colour materials

Most of the fading problems with chromogenically developed images stem from the types of dye used. They are not particularly stable and in other processes longer-lasting types can be used. Thus, if you use silver-dye-bleach processes, you will get prints which are claimed to be much more stable than those from equivalent chromogenic processes. Not only are the image dyes inherently more stable they can also be prepared as complex compounds with metals – a process giving enhanced stability.

52 The French Photographer Brassai, in London. Photographs of archival importance may be chemically treated, after fixing and washing, by various procedures designed to modify or add to the silver image in such a way as to make it more stable. Most involve some change in image colour but this may be tolerable and is, indeed, often attractive.

Similar chemical methods are described as stabilising the images formed in Polaroid 'instant' photographs. No comparable claims seem to have been made for other such processes.

The silver-dye-bleach process should be carried out correctly with due regard to the final wash if you are to obtain the very stable results achievable. Common sense would suggest protecting displayed prints from prolonged exposure to direct sunlight and storing prints under cool dry conditions.

You are entirely in the manufacturers' hands with some instant photographic processes, but in others you have some, limited, scope for error in processing. Generally, however, the potential stability of an instant print is pre-ordained by the manufacturer and you can do little or nothing to improve it at the processing stage. After that, it is a matter of sensible display or dark storage conditions.

Bluntly, it seems that, if archival permanence is your overriding concern then you will do best at the present time to take Kodachrome transparencies and make Cibachrome prints. You will then need storage for the transparencies and prints in a suitably cool, dry atmosphere.

16 TOO LITTLE OR TOO MUCH?

At one time it was quite common to modify black-and-white negatives and prints by suitable chemical aftertreatments. Traditionally, you can increase the image density and, if you wish, contrast by using an *intensifier* solution and a *reducer* to achieve the opposite effect. In fact, such treatments for negatives are rather rarely used nowadays, for a number of reasons. The latitude of modern negative materials, the range of developers available, the systematisation of development control and the range of paper grades obtainable combine to make them generally unnecessary. Also, modern materials do not necessarily behave as expected in the chemical solutions used. So, as with most non-standard procedures, you should do some experiments before committing a precious photograph to the treatment planned.

Intensification

If you have a negative which is too soft or too low in density, perhaps for reasons of development or exposure, then you can try intensification. You should not, however, resort to such a measure until you have exhausted the possibilities of printing on hard grades of paper.

To intensify silver images you generally need to add something to the image. You can add more silver, another metal, a metal compound or even a dye. You should start with a thoroughly washed negative and treat it with a bleach, followed by an intensifying solution which gives an image darker than the original. An example of this type is chromium intensification in which you bleach the image in an acid dichromate solution and then redevelop the bleached image using a normal photographic developer. The bleach formula is shown in fig 16.1.

16.1 Chromium intensification: the bleach.

Potassium dichromate (10% solution)	100ml
Hydrochloric acid (conc)	2.5ml
Water to	1 litre

CAUTION Here, the normal precautions concerning concentrated acids and other chemicals apply. Direct contact with either of the two chemicals used in this formula should be avoided. Skin contamination should be removed immediately by washing off the chemical with large quantities of cold water. If an eye is affected flood it with water for fifteen minutes and then seek immediate medical aid. If you swallow the chemicals, drink a large amount of water and seek immediate medical aid.

In this process the bleached image is composed of silver chloride and chromic oxide. Development yields a slightly intensified image. If the intensification is insufficient you can repeat it after fixing and washing. An alternative is to treat the bleached image with a sulphide solution similar to that used in sepia toning (Chapter 13).

You can obtain greater intensification by the use of a uranium intensifier which gives a yellow-brown image of rather poor long-term stability. The formulae of the solutions used are shown in fig 16.2.

16.2 Uranium intensification.

Solution A	Uranium nitrate	25g
	Water to	1 litre
Solution B	Potassium ferricyanide	25g
	Water to	1 litre

For use, mix 4 parts A, 4 parts B and 1 part of glacial acetic acid. Intensify to the desired extent, rinse in very dilute acetic acid and then wash the negative thoroughly before drying.

Reduction

You may occasionally be faced with an overdense negative or a negative or print in which you wish to clear the lightest areas. Typical applications include the reduction of even the very small density developed in nominally clear areas of line and lith records. You may also wish to selectively reduce the density in a print in order to accent particular areas.

Probably the most common reducing solution is Farmer's reducer, in effect, a very early example of a combined bleach and fixer. It is not stable after mixing and you should discard it after use. It has found application as bleach-fixer in one-shot

16.3 The use of Farmer's reducer.

Part A	Potassium ferricyanide	100g
	Water to	1 litre
Part B	Sodium thiosulphate	200g
	Water to	1 litre

Solutions A and B keep well. For use, add just sufficient of A to B to colour the solution light yellow – approximately one part of A to twenty parts of B.

Treat the image to be reduced only until sufficient reduction is achieved. Then wash the material very thoroughly to avoid staining and, possibly, subsequent fading.

colour processing. The formula of Farmer's reducer is shown in fig 16.3.

You can use Farmer's reducer to subtract a constant amount of density from all areas of a negative or print. This type of reducer is known as a *cutting* or *subtractive* reducer, and its effect is illustrated diagrammatically in fig 16.4. Tone reproduction should not really be affected by reduction in Farmer's reducer and it is therefore particularly useful for treating overexposed negatives.

If you dilute Farmer's reducer its effect will be slower but the reduction may also cease to be of the subtractive type and more silver may be removed from denser than lighter areas in the *proportional* fashion illustrated in fig 16.4. You can use this effect to lower the contrast of an overdeveloped negative and make it printable without significant loss of speed. A suitable formula for a proportional permanganate-persulphate reducer is given in fig 16.5.

Negatives you have underexposed but overdeveloped (Chapter 8) may have too much contrast yet be quite thin in the shadows. Such negatives may benefit if you use a *super-proportional* reducer as shown in fig 16.4. The effect is to greatly reduce high densities but to change the lowest densities by very little. A suitable reducer for this purpose is shown in fig 16.6.

Summary of applications

In seeking to correct negative faults some care is needed in making a proper choice from the wide range of intensifiers and reducers. Fig 16.7 gives a summary of negative faults and prescribed treatments.

Practical points

Intensification and reduction methods for silver images do not always do what you want. Modern emulsions differ considerably from those in use when most aftertreatments were first devised. So it is wise to try out such treatment first on a test strip, spare print or negative which is the same photographic material as the image to be modified. In any intensification process involving a pre-bleach step, make sure that no residual fixer is present in the film by washing it well before putting it in the bleach bath. Failure to wash the film adequately could result in a less intense image than the original.

Aftertreatment on negatives tends to have an adverse effect on the definition and graininess of the final print. You really should aim never to need such processes. But, if you have to use them, avoid extended treatments or undue degrees of intensification. Do the minimum to get a useful print.

Colour images

In desperate circumstances you can, if necessary, attempt to modify the amounts of the image dye present in order to correct the colour balance or overall density of transparencies and prints. The most common procedures reduce the quantity of dye or dyes present.

Chromogenically developed images in most colour materials comprise essentially similar

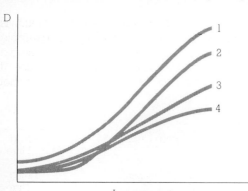

16.4 The effects of different categories of photographic reducer: 1 The original characteristic curve, 2 Treatment with a subtractive or cutting reducer, 3 A proportional reduction in image density, 4 A super-proportional reducer; note the extreme loss of contrast at high densities.

16.5 A proportional reducer.

Part A	Water (distilled)	900ml
	Sulphuric acid (conc)	1.5ml
	Potassium permanganate	0.25g
	Water (distilled) to	1 litre
Part B	Ammonium persulphate	25g
	Water (distilled) to	1 litre

When making up Solution A, stir the water constantly and add the sulphuric acid in drops. Never add water to the sulphuric acid. The cautionary notes in Chapters 4 and 14 apply here also. Use distilled water to avoid the effects of chlorides dissolved in tap water.

For use, mix one part of A with three parts of B. When reduction has gone far enough, remove the negative and immerse it in a 1 per cent solution of sodium bisulphite to clear the by-products of bleaching. Wash thoroughly before drying.

16.6 A super-proportional reducer.

Ammonium persulphate	25g
Sulphuric acid (10%)	10ml
Water (distilled) to	1 litre

When reduction has advanced to nearly as much as required, immerse the negative in a 5 per cent solution of sodium sulphite to prevent further reduction. Wash the negative thoroughly before drying.

The cautionary notes concerning photographic chemicals in Chapters 4 and 14 also apply to the chemicals used in this process.

16.7 Applications of intensification and reduction.

Fault in negative	Cause	Treatment required
Thin and/or low contrast	Insufficient exposure or development	Intensification
Over dense, with correct contrast	Overexposure	Cutting or subtractive reducer
Correct shadow densities but too dense highlights (high contrast)	Overdevelopment	Proportional reducer
Thin shadows but over-dense highlights	Underexposure and overdevelopment	Super-proportional reducer

16.8 Solutions for selectively bleaching yellow image dyes in chromogenic materials.

		Kodak SR-33	Agfa Formula
Solution A	Potassium permanganate	50g	2g
	Ceric sulphate	–	8g
	Water (distilled) to	1 litre	1 litre
Solution B	Water (distilled)	900ml	900ml
	Sulphuric acid (conc)	50ml	–
	Sulphuric acid s.g. 1.28	–	80ml
	Sodium sulphate	115g	–
	Water (distilled) to	1 litre	1 litre
Solution C	Sodium chloride	180g	–
	Water (distilled) to	1 litre	–
Mix for use		1A:2B:200C	1A:1B

Follow SR-33 treatment with immersion in 5 per cent sodium bisulphite solution. After chemical treatment, wash film for 10 min, rinse in dilute wetting agent and dry.

DANGER Sulphuric acid is highly corrosive, avoid contact with person or clothes. In case of accidental contact with the solution flood the affected area with water. When preparing solutions, always add the acid to water with continuous stirring, never add water to the acid.

16.9 Solutions for selectively bleaching magenta image dyes in chromogenic materials.

	Kodak SR-32	Agfa Formula
Disodium salt of ethylene diamine tetra-acetic acid	1g	0.5g
Stannous chloride	10g	5g
Water to	1 litre	1 litre

SR-32: When you have achieved the desired bleaching of the magenta dye, wash for 10 min and wipe the surface clear of white precipitate during the wash.

Agfa Formula 1: Wash the bleached film for 5 min, immerse it in 2% borax solution for 3 min and wash finally for 10 min.

In each case, after the final 10 min wash you should rinse the film in dilute wetting agent and dry it.

16.10 Solutions for selectively bleaching cyan image dyes in chromogenic materials.

	Kodak SR-31	Agfa Formula
Sodium acetate (anhyd)	22g	–
Sodium dithionite	1.5g	–
Metol	–	10g
Potassium metabisulphite	–	10g
Water to	1 litre	1 litre
Dilution for use	–	1 part + 3 parts water

In each case, wash the film for 10 min after you have achieved the required degree of bleaching, rinse in diluted wetting agent and dry.

16.11 Solutions for the simultaneous reduction of all three image dyes (Agfa formula).

Solution 1	Potassium permanganate	10g
	Water to	500ml
Solution 2	Sulphuric acid (s.g. 1.28)	40ml
	Water to	500ml
Solution 3	Potassium metabisulphite	50g
	Water to	1 litre

Mix solutions 1 and 2 together in equal proportions immediately before use. Treat the film with the mixed solution for 5 min (or longer if necessary) and then wash for 5 min. Immerse the film for 5 min in solution 3, wash it for 10 min and dry.

16.12 Formula for the selective bleaching of cyan dyes used in the silver-dye-bleach process.

Sodium dithionite	3g
Sodium bicarbonate	3g
Water to	1 litre

After bleaching, wash the print for ten minutes, rinse in wetting agent and dry.

16.13 Formula for the selective bleaching of magenta dyes used in the silver-dye-bleach process.

Solution A	Chloramine T	15g
	Water to	1 litre
Solution B	Acetic acid (10%)	
Solution C	Sodium bisulphite	10g
	Water to	1 litre

To prepare the working solution, add B in drops to the required volume of A until the white mixture turns, and remains, milky. Treat the print in this solution until you have achieved the required amount of reduction. Rinse in water for 30 sec and then immerse the print in C for 2 min. Finally wash thoroughly for 10 min, rinse with wetting agent solution and dry.

16.14 Formula for the selective bleaching of yellow dyes used in the silver-dye-bleach process.

| N, N-dimethyl formamide | 2 vols |
| Water | 1 vol |

After bleaching, wash for 10 min, rinse in wetting agent and dry.

classes of each colour of dye. This similarity between products is reflected in the similiarities sometimes shown between suggested treatments for selective reduction of individual image dyes. Formulae and procedures published by Kodak and Agfa for their respective reversal films are probably good starting points if you wish to try dye-reduction on films made by any manufacturer. You can attempt to reduce a yellow dye (selectively) by one of the two solutions shown in fig 16.8. In each case you use an acid, strongly oxidising solution.

In fig 16.9 two solutions are quoted for reduction of magenta dye in a transparency. In each case, stannous chloride is present as a chemical reducing agent.

Finally, two solutions are given in fig 16.10 which are designed for bleaching cyan image dyes. In this case the two solutions are quite different.

If you need to correct a transparency for underexposure, Kodak recommend that you use all three dye-reducers successively. Use the yellow bleach first. Wash the transparency for 5 min between bleaches and for 10 min after completion. Agfa, on the other hand, publish a formula which can be used for the reduction of all three dye densities simultaneously. The formula and directions for use are given in fig 16.11.

If you use the silver-dye-bleach process you may wish to modify the quantities of dye present in a print. Ciba have published formulae suitable for selective reduction of the image dyes and these are shown in figs 16.12 – 16.14.

Practical points in dye reduction

While you can find suggested bleach formulae in some manufacturers' data sheets, changes in products and differences between products from different makers mean that the use of such bleaches involves an element of chance. As with all unusual processes, involving a precious photograph do a test with a spare, on the same material, before tackling the important one.

16.15 Negatives which have received insufficient exposure to give prints with adequate shadow detail, as in **A**, can sometimes be saved if you are prepared to intensify them chemically **B**. You will be quite lucky if you can achieve a dramatic improvement without a visible increase in grain. In most cases you are likely to make small but useful improvements and the grain increase may not show. Some incease in contrast is also usually found.

17 WHAT WENT WRONG?

When you do your own developing, some processes may give less than optimum results. If you know what went wrong you can avoid it in future. If you cannot ascribe a cause, you risk the problem sneaking up and ambushing you in the future. An analytical approach will assist in isolating a problem.

Black-and-white negatives

The black-and-white negatives shown in fig 17.1 illustrate the effects of variation in exposure and development. Look at your defective negative and try to fit it into this scheme. Ask yourself a few questions. Are the lightest areas devoid of detail? Is the whole negative light or dark? Does the negative have high contrast, or look flat? The vertical columns in fig 17.1, showing the exposure conditions, illustrate the variation in overall density level. The horizontal rows, representing three development conditions, show variations in negative contrast. Three problem negatives are shown in fig 17.2, together with the best prints made from them.

If you look at negative A in fig 17.2 and answer the suggested questions you will see that: 1, the lightest areas are short of detail – the negative is underexposed; 2, the negative is of high contrast – it is overdeveloped.

So the negative is both underexposed and overdeveloped.

The same questions applied to negative B in fig 17.2 give the answers: 1 The lightest areas have detail – the negative is not underexposed; 2 The whole negative is dark – it is overexposed; 3 The negative is flat – it is underdeveloped.

Lastly, negative C is different again: 1 The light areas lack detail – the negative is underexposed; 2 The whole negative is light – it is underexposed; 3 The negative looks flat – it is underdeveloped.

To some extent, there analysing questions are hard to answer without experience of normal negatives. Fig 17.1 should help. You may find that variation of effective speed with development complicates your decisions. An underexposed, flat-looking negative may well lack shadow detail (detail in the lightest areas of the negative), so you need to think about the contrast as well as the shadow detail.

Once you come to some sort of conclusion about a difficult negative, you should look at the

A

D

G

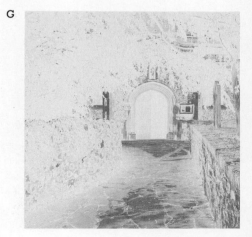

17.1 Negative exposure and development conditions: **A** underexposed, underdeveloped, **B** correctly exposed, underdeveloped, **C** overexposed, underdeveloped, **D** underexposed, correctly developed, **E** correctly exposed, correctly developed, **F** overexposed, correctly developed, **G** underexposed, overdeveloped, **H** correctly exposed, overdeveloped, **I** overexposed, over developed.

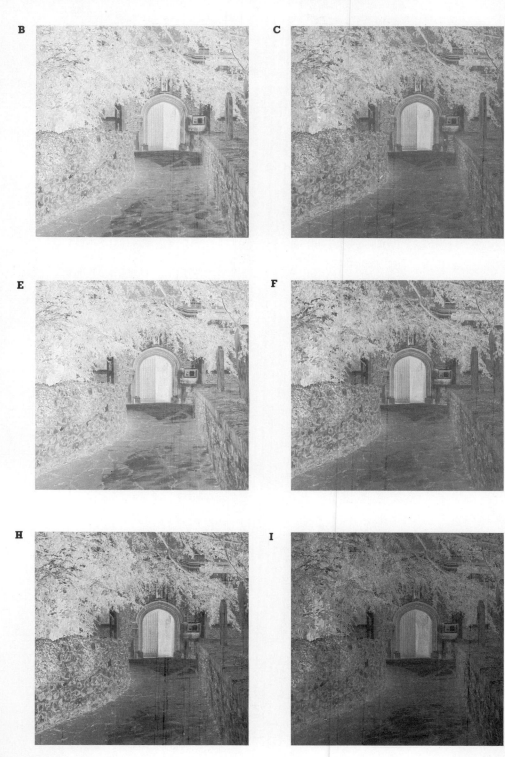

14.5 A pigmented black-and-white bromide printing paper suitable for a range of graphic effects (see Chapter 14).

14.7 The bleach-etch process. The original print is seen at the right hand side while the left hand side shows the effect of the bleach solution in removing both silver and the gelatin, in this case pigmented already (see Chapter 14). (Original Kentint print supplied by Kentmere Ltd.).

Exposed in south-facing window

Protected from light

15.1 The effect of exposure to daylight in a south-facing window for two months, on two commercially made negative-positive colour prints. A slight increase in yellow stain and a decrease in magenta dye (and possibly cyan) content are visible in the prints before reproduction. The changes are not, however, disastrous. (See Chapter 15)

15.2 Album stability. Negative-positive prints made from the same negative and two different printing papers (but originally matching) are compared after 16 years' storage. One of the prints is seen to have faded unacceptably, notably by loss of the cyan dye. The other print is still visually acceptable — see Chapter 15. (Illustration courtesy of Polytechnic of Central London.)

17.4 Underexposure of a colour negative. The boy's clothing is deep blue but, although the skin tone is nearly acceptable, the degree of underexposure ruins colour reproduction in all but the light areas of the subject.

rest of the film. You would expect an over- or underdeveloped negative to be one of a set comprising the entire film. If there seems to be a random variation among the negatives the exposure is a probable cause. Confirm whether this is the case with the single negative in question.

Underdevelopment can arise from a number of causes. First, the developer itself may be exhausted, either from developing films or through atmospheric effects. The developer may have been accidentally diluted with water or, worse, may have been contaminated with stop or fixing solutions. Another three causes, all easily controlled, are inadequate time, agitation or temperature.

Black-and-white prints

Even with a good negative, you can still have printing difficulties if all is not well with the print developer. Fig 17.3 shows the effects of diluting the print developer on prints made from a normal negative on normal paper and given optimum exposure for the standard development conditions.

Increasing dilution by a factor of 2 between each pair of prints A-B, B-C, C-D, causes a small reduction in print contrast. The further factor of 2 between D and E, however, produces a catastrophic loss of contrast (as well as a much warmer image tone). All the test solutions were fresh and differences in long-term performance could not therefore be detected by the experiment.

It helps you to build up experience if you record all that you do in sufficient detail to be able to repeat any operation later. Among the useful data should be dates of mixing or purchase of developers, dates of printing and the quantity of materials processed in the solutions concerned, the temperatures used and so on. Such data helps you to ascribe a cause to, for example, the identified

58 An all-too-common fault seen in prints is due to uneven drying of the negative. In this case you can see only one edge of the drying mark – a near vertical diffuse line.

17.2 Problem negatives and the best prints made from them (for details see the text).

A Dark areas of the print lack detail and look 'muddy', the negative therefore was *underexposed;* sunlit areas are a little high in contrast and harsh. Was the negative *overdeveloped?* Confirm by looking at the negative.

B Highlight and shadow areas both have plenty of detail and there is adequate contrast throughout the print. The negative was *not underexposed* (it needed grade 4 paper as the negative was *underdeveloped).*

C Pronounced lack of shadow detail, the negative was *underexposed,* harshness in sunlit areas suggests that a very hard grade of paper was required to produce the print and this indicates either worse underexposure than A or similar underexposure but also accompanied by *underdevelopment.* The negative was probably both *underexposed* and *underdeveloped.* It could just be a worse case of A: look at the negative to confirm overall lack of contrast as well as underexposure. Look at the negative as well as the print.

underdevelopment of a film.

Another type of processing error involves unevenness in the photograph – negative or positive. The causes are legion, but a number of such faults can crop up in processing. The commonest is probably due to inadequate agitation. The negatives may have streaks emanating from areas of high density or from the perforations of 35 mm film – typical developing faults. Faults in fixing are less common although an exhausted fixer or poor washing may result in the subsequent formation of dark patches or stained areas which get worse with the passage of time. Other patchy markings can arise from careless handling or even partial fogging of the film or paper by light.

Correction of faults

Most fault correction consists of finding causes and preventing a repetition of them. Correcting an already affected photograph may not be possible. 'Spotting' prints or retouching negatives with suitable dyes is a way to correct some small defects or even large-scale density variations observable in the photograph. To some extent you can compensate for uneven development in a negative by 'dodging', that is, locally modifying exposure at the printing stage.

Colour transparencies

If your colour transparencies simply look too light or too dark they may have received too much, or too little, exposure respectively. First, make sure that the effect is consistent. If it is, you should check your method of exposure assess-

A

ment and perhaps think about rating the film at a speed which gives good results in your system. It may be that you are consistently over- or under-developing your films in the first developer due to over- or under-agitation, high or low temperature or an incorrect development time. All these are, in principle, within your control and all should be checked.

A consistent colour cast at all tone levels, other than clear highlights, can be caused either by exposure or processing conditions. A few lighting errors are common. A blue cast appears when artificial light film is exposed in daylight, a warm orange cast with daylight film exposed in typical domestic tungsten lighting and, often, a greenish cast is seen on daylight-film exposed under fluorescent lighting. If indi-

vidual frames of a single film show different colour casts then processing is probably not to blame. If the whole film has a cast and you decide that you have used the correct exposure conditions, then processing is probably the cause. Check that you have used correct times, temperatures and agitation in all solutions and pay particular attention to colour developer and bleach stages. An inability to form a full black, even in the unexposed areas outside the frames, can be due to failure in the reversal step – either an incorrect chemical solution. or exposure to light.

Prints made from transparencies using reversal colour paper can suffer from much the same faults as reversal colour film, and with similar causes. (Note, incidentally, that a transparency with a

B

C

A

B

C

D

17.3 Dilution of the print developer. These prints show the effects of developer concentration on the appearance of prints given standard exposure and development times:

A undiluted stock solution used, **B** 1 stock + 1 water, **C** 1 stock + 3 water, standard concentration, **D** 1 stock + 7 water, **E** 1 stock + 15 water.

E

poor colour balance will probably not give a satisfactory print.) There is one particular processing fault that you may find on a print. Some of the reversal paper processes are prone to streaking which arises from agitation deficiencies in some drum processors. Check, in advance, the suitability of such equipment for any process you wish to carry out.

In all colour processes you may get rather disagreeable photographs if the colour balance changes with the image density. This is due to mismatches of contrast between the sensitive layers in the transparency or the print material. Typically, this results in cyan highlights and reddish shadows – very unpleasant since Caucasian skin tones become rather cadaverous and not at all flattering. Almost any other different colorations can, similarly, occur in highlights and shadows. The causes can be quite

complex and you should carefully check your methods of work. If all is well, then the problem is either chemical or due to a faulty paper batch (or paper that has deteriorated through unsuitable storage conditions). If you can change one or the other singly, then try to pin down the cause. The paper or chemical manufacturers often provide trouble-shooting guides to help you solve processing problems.

Negative-positive colour
A major difference between positive-positive and

negative-positive colour is that, in the latter, the camera film has an image that is nearly impossible for you to assess for colour visually. Thus, you can have little idea of the quality of colour reproduction before seeing the final print. On the other hand, overall colour balance is easily adjusted by filtration during printing.

You can, however, visually check the exposure level of a colour negative. As with black-and-white negatives, an absence of detail in the lightest areas indicates underexposure. This is particularly serious with colour negatives. You will have great difficulty in making a good print from an underexposed negative. There are only two grades of colour paper generally available so that the scope for rescuing underexposed or underdeveloped negatives is restricted. You are also likely to experience colour balance problems, particularly with the shadows; an example is shown in fig 17.4. Moderate overexposure of colour negatives will prove less of a problem to you and the prints may well be satisfactory. A correctly exposed colour negative will show substantially greater contrast in shadow detail than will a black-and-white negative. The rather low exposure levels that can be accepted in black-and-white negatives will tend to give poor colours in the shadows.

Correction of faults

The dye reduction solutions described in Chapter 16 can be used in an effort to correct general or local colour balance in colour transparencies. To attempt the latter successfully you require some skill with a fine brush. Prints can be modified by the use of transparent or opaque retouching colourant. You can only use transparent retouching dyes if you have to correct a transparency but either type of colourant is suitable for paper prints.

As with other operations in colour processing, keeping proper records will help you in building up experience and perfecting what you do. Some sort of systematic record can be set up that is informative but not too onerous to keep up to date.

Not your fault?

Even if you have not processed a film or some prints yourself but have had the work done by a laboratory there is no reason why you should not be critical about the results. If something is wrong try to work out what it was. Has the photograph

59 Inadequate fixing and washing of prints can lead to objectionable staining later. In this photograph uneven staining is seen in the very light sky areas.

been underdeveloped, underprinted or simply printed with the wrong colour balance? If you are sure that the error is not at the taking stage then you have grounds for complaint to the laboratory. Some of the most annoying faults are those in which otherwise perfect photographs show mechanical damage. This can be random and caused by a simple accident in handling the photographic materials, or it can be systematic and caused perhaps by a processing machine. Such effects include lengthwise scratching of the film due to grit in the light trap of the cassette, or in a continuous type of processing machine. Roller-transport machines can, if inadequately maintained, impress a repeat pattern on the film all along its length. Such a pattern can range from a slight surface smearing (due to a dirty roller), which you can try to clean off, through to a repeating physical abrasion which you cannot successfully correct.

In all processed films there is a slight risk of drying marks if the process is not properly maintained. Such marks are most likely to be on the back of the film base rather than on the emulsion surface. You can try to remove these marks with a cotton wool swab and a little dilute wetting agent. Try to avoid getting the solution on the emulsion (nearly matte) side of the film. If you do, finish your cleaning-up job, rinse the entire piece of film in the wetting agent and then dry it. This treatment, however, may not leave the emulsion in the optimum condition for dye stability. The best result may be obtained by a final treatment in the last solution of the process concerned – if this can be arranged.

Quality control

Processing laboratories commonly use quality control test strips, pre-exposed by a film manufacturer and developed with the film batches, to assess how good their processing is. Instructions for such procedures are obtained from the manufacturer who provides considerable amounts of data to assist in trouble-shooting.

The small-scale user would probably find this kind of quality control quite uneconomic, but there are things you can do to assess the consistency of your processing. When making colour prints, test consistency by keeping a master negative or transparency, printing it from time to time and noting the printing conditions for a print matching a standard result or, more easily, by using standard printing conditions and noting any departures from the standard result.

It is worthwhile trying to establish a cause for such departures and your record book can help by reminding you of when changes of materials, chemicals or even enlarger bulbs were made. Faulty or exhausted chemicals can also be revealed by the 'standard print' technique. It may not be easy to interpret the colour problems when printing a particular negative for the first time. A suitable master camera record, negative or positive, can be very helpful.

The master photograph

The subject matter of a master photograph should be chosen with care. The most critical subjects for colour assessment are neutrals and skin tones. Pastel colours can also be informative, as can some vivid colours. You can create a very suitable test subject by making an array of coloured paper samples comprising neutrals, from white through a scale of greys to black, and some of the colours mentioned above. Such a colour test chart is the subject of the two colour prints shown in fig 15.2. A suitable model can then, if you wish, be photographed together with the test chart, or on an adjacent frame, using as standard lighting as you can arrange. Electronic flash is usually quite reproducible. Such a test subject can give you master negatives and transparencies to assist your printing and can also be photographed, if required, to test the exposure and processing of camera films.

Once you have a system capable of producing consistent exposures of a standard, critical, test subject you can set up a system of quality control.

This should reveal any problems and, by helping you to solve them, enable you to get the best out of photographic developing.

BIBLIOGRAPHY

Adams, A., *The Negative*, Morgan and Morgan, Hastings on Hudson (1968).

Illustrates the importance of control in the development of the negative. Gives useful information on technique and some formulae of solutions.

Coote, J. H., *Monochrome Darkroom Practice*, Focal Press, London (1981).

A useful guide to some darkroom operations with good background information on the manufacture of films and papers.

Hunt, R. W. G., *The Reproduction of Colour* (3rd ed), Fountain Press, London (1975).

A standard work containing background information on the perception and reproduction of colour by photographic and other means.

Ilford Ltd., *Good Picture Guide*, Ilford Ltd. (1981).

Useful details of a range of developers and black-and-white products.

Jacobson, R. E., *L. P. Clerc's Photography Theory and Practice: 4 Monochrome Processing* (revised ed), Focal Press, London (1971).

The technical background to monochrome processes with details of the chemical mechanisms involved.

Jacobson, K. I. & Jacobson, R. E., *Developing* (18th ed), Focal Press, London (1978).

Contains an account of the technicalities of developing including details of processing machines and an unrivalled formulary for those wishing to make up solutions.

Jacobson, R. E., Ray, S. F., Attridge, G. G. & Axford, N. R., *The Manual of Photography* (7th ed), Focal Press, London (1978).

A general technical work of reference with useful information on colour processes.

Kodak Handbook for the Professional Photographer, Vols 1–4, Kodak Ltd. (current edition) and Formulary (1975).

Full details of Kodak products and appropriate processing as well as descriptions of darkroom practices.

Taylor, J., *Colour Printing in Practice*, Element/David and Charles, Newton Abbot (1984).

Includes useful step-by-step instructions for the processing of colour print materials.

Thomas, W. (Jr) (ed), *SPSE Handbook of Photographic Science and Enginering*, John Wiley, New York (1973).

Contains formulary and advanced technical and chemical details of photographic systems.

Walls, H. J. & Attridge, G. G., *Basic Photo Science* (2nd ed), Focal Press, London (1977).

A general introduction to the science underlying the photographic process. Contains explanations of the technicalities for the intelligent lay person.

ACKNOWLEDGEMENTS

The author wishes to thank:

Barbara and Alexander for their forebearance and sympathetic assistance, Paul Petzold and Ralph Jacobson for assistance and helpful discussions, The Polytechnic of Central London for the use of illustrative material and technical information from the Photographic Technology Research Group.

The pictures numbered 3, 4, 5, 6, 11, 12, 15, 18, 25, 30, 32, 33, 35, 36, 37, 45, 46, 47, 48, 49, 53, 54 are by the author. Others are as follows:

Roger Clark 1, 7, 10, 21, 52.

Ed Buziak 2, 8, 9, 13, 14, 16, 17, 19, 20, 22, 23, 24, 26, 27, 28, 29, 31, 34, 38, 39, 40, 41, 42, 43, 44, 50, 51.

Polytechnic of Central London 15.2 (A and B).

INDEX